S0-AVI-362

✓ **Checklist continued on back inside cover**

Awesome SOCIAL MEDIA Quizzes

Follow us on social media!

Tag us and use #piccadillyinc in your posts
for a chance to win monthly prizes!

© 2018 Piccadilly (USA) Inc.

This edition published by Piccadilly (USA) Inc.

Piccadilly (USA) Inc.
12702 Via Cortina, Suite 203
Del Mar, CA 92014
USA

10 9 8 7 6 5 4 3 2 1

Printed in China

ISBN-13: 978-1-62009-466-2

What 80s craze are you!

The 80s defined a generation, whether they liked it or not. There's no mistaking the styles and trends of this decadent decade. Whether you were raised in it, or you missed growing up in it, it's time to find out which signature craze you would have been.

1. What is your favorite thing about the 80s?
 A. The games
 B. The hairstyles
 C. The fashion
 D. The accessories
 E. The music

2. What was your favorite 80s TV show?
 A. Facts of Life
 B. Dukes of Hazzard
 C. Punky Brewster
 D. Knight Rider
 E. The Cosby Show

3. If you could bring back one popular 80s food, what would it be?
 A. Ring Pop
 B. Big League Chew
 C. Tab
 D. Pop Rocks
 E. Pudding pops

4. What is your all-time favorite 80s movie?
 A. Ghostbusters
 B. Back to the Future
 C. Sixteen Candles
 D. Weird Science
 E. Footloose

5. What slang from the 80s sounds like something you'd say?
 A. Righteous
 B. Gnarly
 C. Totally
 D. Duh
 E. Psych

6. What movie genre was best in the 80s?
 A. Comedy D. Sci-fi
 B. Horror E. Action
 C. Romance

7. What was your least favorite thing about the 80s?
 A. The fashion D. The language
 B. The cars E. The hairstyles
 C. The food

8. Choose one fashion trend you love:
 A. Spandex D. Penny loafers
 B. Denim jackets E. Gold chains
 C. Jelly shoes

9. Choose one fashion trend you hate:
 A. Lace gloves D. Parachute pants
 B. Shoulder pads E. Rubber bracelets
 C. Blue mascara

10. Who is your cartoon hero?
 A. She-Ra: Princess of Power D. He-Man
 B. Alvin and the Chipmunks E. Thundercats
 C. Duck Tales

Score Guide

1. A=1, B=2, C=3, D=4, E=5 **2.** A=1, B=2, C=3, D=5, E=4 **3.** A=3, B=1, C=2, D=4, E=5
4. A=2, B=4, C=3, D=1, E=5 **5.** A=5, B=2, C=1, D=3, E=4 **6.** A=5, B=1, C=3, D=4, E=2
7. A=2, B=3, C=4, D=1, E=5 **8.** A=3, B=2, C=1, D=4, E=5 **9.** A=2, B=1, C=4, D=3, E=2
10. A=3, B=1, C=4, D=2, E=5

Your Total Score _____

Results

10-17 Rubik's Cube

You may be a cube, but you're no square. Lighthearted, playful and colorful, you would have loved everything about the 80s. You are specifically drawn to the arcade scene.

19-25 Mullet

You are all about the action scene. You have a bit of the rebel in you, and you hate conformity. The 80s brings out your love of freedom of expression.

26-33 Leg Warmers

Hello, fashionista! You are hot on the social scene and in the mix at every party. If Facebook were around in the 80s, you would have had thousands of friends.

34-41 Fanny Pack

You may have been a nerd in the 80s, but the nerds of yesterday are today's entrepreneurs. An appreciation for knowledge draws you to a select few people, and you rely on a small group of close friends. You don't fit in with mainstream, but you don't care.

42-50 Boom Box

Pump up the volume! You are an 80s music buff with a dedicated group of friends. You are outgoing, have a great sense of humor and consider yourself an up and coming star.

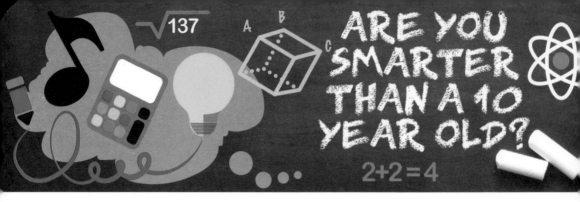

How well have you retained what you learned in primary school? You're about to feel like a genius, hopefully.

1. Which of the following animals is not a fish?
 - A. Clown Fish
 - B. Sea Horse
 - C. Nurse Shark
 - D. Humpback whale
 - E. Marlin

2. Without a calculator, what is 8 x 9?
 - A. 72
 - B. 68
 - C. 81
 - D. 74
 - E. 64

3. Which word is spelled correctly?
 - A. Acommadate
 - B. Accommodate
 - C. Accomodate
 - D. Accommedate
 - E. Accomadate

4. Choose the correct word to fill in the blank: "James hasn't called _____ he got back from vacation."
 - A. Before
 - B. While
 - C. Since
 - D. Until
 - E. After

5. There are 5 boxes on the desk. Each box contains at least 10 rocks but not more than 14 rocks. Choose which answer could be the total number of rocks in all five boxes.
 - A. 75
 - B. 65
 - C. 35
 - D. 45
 - E. 25

6. Without looking at a photo or flag, how many stripes are on the American flag?

 A. 20
 B. 13
 C. 12

 D. 15
 E. 9

7. In what city would you find Big Ben?

 A. Tokyo
 B. Berlin
 C. Seattle

 D. Paris
 E. London

8. Frogs and turtles are types of _____.

 A. Amphibians
 B. Lizards
 C. Arthropods

 D. Echinoderns
 E. None of the above

9. Without using a calculator, what is 3.65 + 5.95?

 A. 8.9
 B. 9.6
 C. 9.55

 D. 8.85
 E. 9.3

10. Which word in the following is a collective noun: "Mary tends a flock of sheep."

 A. Sheep
 B. Mary
 C. Flock

 D. Tends
 E. None of the above

Score Guide

1. A=0, B=0, C=0, D=5, E=0 **2.** A=5, B=0, C=0, D=0, E=0 **3.** A=0, B=5, C=0, D=0, E=0
4. A=0, B=0, C=5, D=0, E=0 **5.** A=0, B=0, C=0, D=5, E=0 **6.** A=0, B=5, C=0, D=0, E=0
7. A=0, B=0, C=0, D=0, E=5 **8.** A=5, B=0, C=0, D=0, E=0 **9.** A=0, B=5, C=0, D=0, E=0
10. A=0, B=0, C=5, D=0, E=0

Your Total Score _____

Results

0-15 It happens to the best of us.

Think of all the things you know that a 10-year-old doesn't. It'll ease the sting.

20-35 But can a 10-year-old balance a check book?

You performed admirably, but you're not exactly a champion. You're half the 10-year-old you used to be.

40-50 Aren't you relieved?

You are vindicated. A shining beacon of adulthood. After years of accumulating life knowledge, the basics still haven't fallen out to make room.

$5 \times 5 = 25$

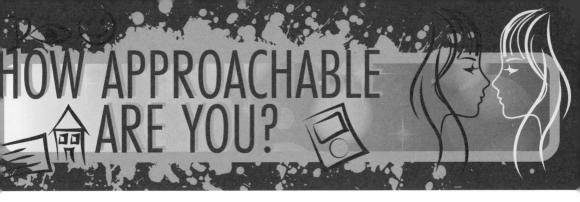

HOW APPROACHABLE ARE YOU?

Are you easy to approach or do you unintentionally scare people off? Do you give off a mean vibe or do you attract people with a welcoming smile? Take this quiz to find out!

1. What is your level of optimism?
 A. The glass is half empty
 B. I have some but not enough
 C. Normal
 D. I'm optimistic
 E. The glass is always full

2. How often do you smile and say hello to strangers?
 A. All the time
 B. Often
 C. Never
 D. Depends
 E. Occasionally

3. Do you hold the door open for people?
 A. Occasionally
 B. Not really
 C. All the time
 D. If I have time
 E. Yes

4. What is your daily facial expression?
 A. I'm usually silly
 B. I don't really have an expression
 C. It varies on my mood
 D. Usually rolling my eyes
 E. I'm always smiling

5. Where is your favorite place to hang out?
 A. Social events and parties
 B. The mall
 C. A good coffee house
 D. Movie theater
 E. My house

6. What are you addicted to most?
 A. Video games
 B. TV
 C. My cell phone
 D. Shopping
 E. My friends

7. How often are you on social media?
 A. At least once a day
 B. Several times a day
 C. I don't get on social media
 D. All day, every day
 E. A few times a week

8. Do you care what other people think about you?
 A. No I don't care
 B. Not really
 C. It somewhat matters to me
 D. Yes it matters
 E. It means everything to me

9. How much of an emphasis do you put on your daily appearance?
 A. It's very important to me
 B. Depends on the occasion
 C. I don't really think about it
 D. I try to look nice
 E. I make a good effort

10. How well do you take compliments from random people?
 A. I don't give it a second thought
 B. It's nice but not important
 C. It can be reassuring
 D. I compliment back
 E. I love them

Score Guide

1. A=1, B=2, C=3, D=4, E=5 **2.** A=5, B=4, C=1, D=2, E=3 **3.** A=3, B=1, C=5, D=2, E=4

4. A=4, B=1, C=3, D=2, E=5 **5.** A=5, B=4, C=3, D=2, E=1 **6.** A=1, B=3, C=2, D=4, E=5

7. A=3, B=4, C=1, D=5, E=2 **8.** A=1, B=2, C=3, D=4, E=5 **9.** A=5, B=2, C=1, D=3, E=4

10. A=1, B=2, C=3, D=4, E=5

Your Total Score _____

Results

10-17 Not really approachable

People do not get a warm, welcoming vibe and will more than likely not interact with you for fear of offending you. You need to lower your wall and try and make yourself open to new possibilities. Stop being such a loner.

19-25 Mildly approachable

You don't make a big effort to consort with new people. You usually keep yourself busy and send off "I'm too busy to be bothered" signals. If you don't slow down and open your eyes, you may miss something great.

26-33 Pretty approachable

You are courteous but cautious. You take life as it comes and like it when something unexpected works out. You can be reserved, and that makes you harder to approach at times, but the right person will take a chance.

34-41 Very approachable

People find you outgoing and easy to take to. You make new friends quickly, and often make strangers feel welcomed in new situations. You are friendly and courteous.

42-50 Extremely approachable

You are easy to approach and make yourself available. Sometimes you're too approachable and should use more caution in certain situations. You document your every move on social media and love the attention. You are outgoing and friendly but should be careful not to attract the wrong kind of attention.

WOULD YOU SURVIVE IN THE WILDERNESS?

We find out a lot about ourselves by how we respond to stressful situations. But only if we live to tell about it. How would you do if you were forced to rough it without a phone or camping gear? Would you return in triumph or be forever lost to obscurity?

1. You don't have a compass. How do you know which way is north? (Assume you're in the northern hemisphere.)

 A. Moss only grows on the north side of trees.

 B. I have no idea. I'll just walk and hope for the best.

 C. Shadows move from east to west. By marking their positions every 15 minutes I can find north.

 D. Follow the north star. It's also visible in the daytime.

2. You are hungry. The best things to eat in the forest are:

 A. Bugs, tree bark, acorns

 B. Berries, bugs, frogs

 C. Mushrooms, berries, frogs

 D. Acorns, bugs, mushrooms

3. Better stay hydrated! The best water source is:

 A. Streams and springs

 B. My own body

 C. The ocean

 D. Rain

4. It's getting dark. To start a fire without matches or a lighter, you should:

 A. Use dead or dry foliage

 B. Rub two sticks together really fast and low

 C. No lighter or matches? Not possible.

 D. Cup your hands to direct the strength of the sun into your tinder

5. If you see a bear, you should:

 A. Very slowly back away while speaking in a calm voice.

 B. Yell at it. They are not used to humans and will be startled, which will give you a head start.

 C. Run and climb the first tree you can.

 D. Freeze in place and wait for it to go away.

6. What is the most important thing your body needs to survive?

 A. Conserved energy C. Water

 B. Warmth D. Food

7. How do you keep yourself busy?

 A. Just keep moving as far and fast as I can C. Build a shelter

 B. Stay put and expend as little energy as possible until I am found D. Make the biggest, brightest fire I can to signal help

8. The best way to take shelter is:

 A. Dig a hole and cover it with sticks and branches C. Make a big pile of leaves and moss and crawl under it to sleep

 B. Climb a tree and hang out on a big branch out of reach of animals D. Lean big sticks and against a tree and cover them with leafy branches

9. Is anyone looking for you?

 A. I think I mentioned my trip to couple of people... C. My sister definitely called the authorities when she didn't hear from me by this morning.

 B. Probably not. I travel alone and leave spur-of-the-moment. D. I've been making S.O.S. signs with rocks and sticks, so someone will see them soon.

10. What's the best way to find civilization?

 A. Follow flowing water C. Get to the highest vantage point you can

 B. Walk downhill D. Look for power lines

Score Guide

1. A = 1, B = 2, C = 4, D = 3 **2.** A = 4, B = 2, C = 1, D = 3 **3.** A = 4, B = 1, C = 2, D = 3

4. A = 3, B = 4, C = 2, D = 1 **5.** A = 4, B = 1, C = 2, D = 3 **6.** A = 1, B = 3, C = 4, D = 2

7. A = 3, B = 2, C = 4, D = 1 **8.** A = 2, B = 1, C = 3, D = 4 **9.** A = 2, B = 1, C = 4, D = 3

10. A = 3, B = 2, C = 4, D = 1

Your Total Score _____

Results

10-15 You wouldn't last an hour.

Sorry, dude. You not only know nothing about surviving in the woods, you think you know a great deal, which is only helpful at parties, which you won't be attending anymore because you are never seen or heard from again and no one knows what happened to you.

16-23 You'd make a valiant effort and ultimately perish.

Nice try. You know your limitations and don't try to be a hero, but unless Crocodile Dundee shows up soon, you're not going to last long.

24-31 You are rescued quickly.

Fair play to you. You're no Grizzly Adams, but you made enough correct choices to stay in one piece until help arrives.

32-40 MacGyver has nothing on you!

You could have lived quite comfortably off the grid for the rest of your life, but your mad roughing it skills brought you back to the world of indoor plumbing, safe and sound, with a lifetime of bragging rights.

WOULD YOU SURVIVE IN THE WILDERNESS?

WHAT DOG BREED ARE YOU?

They say you can tell a lot about a person by their dog, but what can you tell about yourself AS a dog?

1. There's a toy on the floor that doesn't belong to you. Would you rather:
 A. Declare it yours, obviously.
 B. Find its owner and make sure it gets put away immediately.
 C. Sleep on top of it.
 D. Play with it and then hide it for later.
 E. Carry it around until someone throws it for you.

2. You are at a park with your human. Would you rather:
 A. Meet all the humans, sniff all the dogs, and pee on all the trees.
 B. Bark at anything bigger than you, which is everything.
 C. Show off your mad Frisbee skills.
 D. Whatever my human wants to do as long as we're together.
 E. Find my dog friends and plot world domination.

3. You are covered in mud. Would you rather:
 A. What? There's mud on you? Oh well.
 B. Leave it on. You smell awesome.
 C. Ick! Bath time, stat!
 D. Deal with it when your chores are done.
 E. Make fun paw print patterns.

4. Play time! Would you rather:
 A. Work on my agility. I am very fast and bendy.
 B. Play find the treat.
 C. Squirrel!
 D. Fine, I'll play or whatever, but only for a minute.
 E. Lollop around with a ball or stick.

5. A stranger is approaching your human. Would you rather:
 A. Bark and nip until they know who's boss.
 B. Puff up my chest in an intimidating manner until I'm sure this one's okay.
 C. Sniff every part of them I can reach.
 D. Wag down to my very soul.
 E. Captivate them with my gorgeousness to earn their praises.

6. Your human is leaving for work and you are home alone for the day. Would you rather:

 A. Finally find out what's in your human's closet.

 B. Sulk on the couch until they're home, then greet them with all my love and attention so they'll never leave me again.

 C. Make rounds so all is in order when they get home.

 D. Make them earn my affection back when they get home. No one leaves me!

 E. Watch the world out the window and bark at everything that moves.

7. Your human will give you anything you want for dinner. Would you rather eat:

 A. Pizza

 B. A morsel of fine salmon mousse

 C. An enormous, rare steak

 D. Sushi

 E. Hot dogs

8. You and your human are watching a movie on the couch. Would you rather watch:

 A. Romantic drama

 B. A documentary

 C. Home movies

 D. An action flick

 E. A comedy

9. You did something you knew you weren't supposed to. Would you rather:

 A. Clean it up before your human gets home.

 B. Roll in it. Become one with the mess.

 C. Pretend it's not there.

 D. Lay down next to it in misery and never forgive yourself.

 E. Use your face to try to push it under the couch but mostly drool on it.

10. You and your human are going out. Would you rather:

 A. Go for a long walk on the beach. Splashing aplenty.

 B. A hiking trail in the woods.

 C. Hunt smaller animals and make them your minions.

 D. Visit a café in a cute doggy purse.

 E. Go to a farm and show 'em how it's done.

Score Guide

1. A=2, B=1, C=4, D=3, E=5 **2.** A=5, B=2, C=1, D=4, E=3 **3.** A=4, B=5, C=2, D=1, E=3

4. A=1, B=3, C=5, D=2, E=4 **5.** A=2, B=4, C=3, D=5, E=1 **6.** A=3, B=5, C=1, D=2, E=4

7. A=5, B=2, C=4, D=1, E=3 **8.** A=2, B=1, C=5, D=4, E=3 **9.** A=1, B=3, C=2, D=5, E=4

10. A=5, B=4, C=3, D=2, E=1

Your Total Score _____

Results

10-17 **Australian Shepard**

You are an over-achiever. You're organized, sophisticated, exuberant, and work-oriented. You love to have something to do, and you're usually better at it than anyone else.

18-25 **Chihuahua**

Didn't they get the memo? You're the boss. Sassy, independent, and fierce, you know what you want and you go for it with no apologies. You do not strive for perfection; you are perfection.

26-33 **Dachshund**

You're a great friend, but you're also curious and mischievous. You often get into a pickle, but in the most adorable way, and no one can stay mad at you for long.

34-41 **Rottweiler**

Snuggly things come in big packages. You are protective of your friends and family, but once you warm up you are a loving, dependable, and often goofy companion.

42-50 **Black Labrador**

You're everyone's best friend and are always greeted with a smile. Outgoing, devoted, and up for anything, the world is your happy dance. You make up for your imperfections with loyalty.

WHAT DOG BREED ARE YOU?

WHAT ANIMAL WERE YOU IN A PAST LIFE?

In your past life, did you fly, swim, climb or run? Were you big or small? We all have a kindred spirit with animals, do you know what yours is?

1. If you could have one special power for a day, what would it be?
 A. Flying
 B. Breathe under water and manipulate the weather
 C. Unlimited strength
 D. Read other people's minds
 E. Teleportation

2. Which of these traits do you admire most?
 A. Patience
 B. Intelligence
 C. Courage
 D. Loyalty
 E. Honesty

3. Pick your favorite quiet place?
 A. Cemetery
 B. Beach
 C. Treetop
 D. Mountains
 E. Desert

4. Pick your favorite element?
 A. Fire
 B. Sun
 C. Water
 D. Earth
 E. Wind

5. Which of these activities do you like doing most?
 A. Writing poetry
 B. Swimming
 C. Sleeping
 D. Martial Arts
 E. Exploring

6. What animal scares you the most?
 A. Elephant
 B. Bear
 C. Wolf
 D. Shark
 E. Snake

7. What color do you most associate with?
 A. Black
 B. Blue
 C. Gold
 D. Silver
 E. Red

8. What trait best describes you?
 A. Peaceful
 B. Observant
 C. Noble
 D. Dominant
 E. Protective

9. What do you do when you're afraid?
 A. Listen carefully
 B. Retreat to a place I feel safe
 C. Fight or attack
 D. Surround myself with friends or family
 E. Seek peaceful surroundings

10. What makes you happiest?
 A. Rainy Days
 B. Sunsets and sunrises
 C. Relaxing
 D. Family
 E. Independence

Score Guide

1. A=5, B=2, C=3, D=4, E=1 **2.** A=2, B=1, C=4, D=3, E=5 **3.** A=1, B=2, C=5, D=4, E=3
4. A=5, B=3, C=2, D=4, E=1 **5.** A=1, B=2, C=3, D=4, E=5 **6.** A=3, B=4, C=1, D=2, E=5
7. A=1, B=2, C=3, D=4, E=5 **8.** A=2, B=1, C=5, D=3, E=4 **9.** A=4, B=5, C=3, D=1, E=2
10. A=1, B=5, C=4, D=3, E=2

Your Total Score _____

Results

10-17 Raven

You were a raven: watchful, mysterious and observant. You like time alone in quiet places. You're artistic with an emphasis on writing, and you're overly emotional. Your artistry and creativity make you feel alive and free.

18-25 Whale

You were a gentle, intelligent whale. You're a free-spirited and caring person who loves to travel. You care about the planet, and environmental issues are near to your heart. You are calm and peaceful but won't allow yourself to be bullied. Your motto is live and let live.

26-33 Lion

You were an aggressive and dominant lion. You make sure people know how strong you are mentally and physically. You love your family and friends and are very dependable. You don't trust many people, but you will do anything for those closest to you.

34-41 Wolf

Your loyal and protective qualities make you a true pack animal. You are cautious and stealthy and think before you act. You have an explorative nature and always want to provide for your family. You have great leadership skills, but you can sometimes be shy.

42-50 Eagle

You are noble, honest and full of integrity. People look up to you and often want your advice. You always like doing what is right, and you love helping your fellow man. You have traditional values but keep an open mind and always love learning new things.

WHAT ANIMAL WERE YOU IN A PAST LIFE?

How affectionate are you?

Are you a total mush, or are you too rough around the edges and could use some extra hugs? Find out by taking this quiz!

1. Do you like holding hands?
 A. No
 B. To help someone cross the street?
 C. Occasionally
 D. It's romantic
 E. I love it

2. Do public displays of affection bother you?
 A. It's inappropriate
 B. Yes
 C. No, within reason
 D. I think it's sweet
 E. I do it all the time

3. Do you like cuddling?
 A. Don't touch me
 B. It's mostly uncomfortable
 C. I love it
 D. Sometimes
 E. Daily cuddles are a requirement

4. What is your favorite type of movie?
 A. Action
 B. Documentaries
 C. Sci-fi
 D. Scary movies or thrillers
 E. Romantic movies or comedies

5. Which activity do you like most?
 A. Long walks on the beach
 B. Reading
 C. Video games
 D. Horseback riding
 E. Working out

6. What is your favorite thing about being in a relationship?

 A. Having someone to talk to D. The act of loving and caring for someone

 B. Not feeling lonely E. Everything

 C. I'm not a relationship person

7. Do you like writing mushy and sweet things about your sweetie on social media?

 A. Yes D. All the time

 B. No E. Just for big occasions

 C. That's embarassing

8. What do you think about romance?

 A. It's nice with the right person D. I think it's ok but I'm not really romantic

 B. It's important E. I'm a true romantic at heart

 C. I don't think about it

9. How often do you let your significant someone know how you feel?

 A. Often D. Seldom

 B. When we are alone E. I don't talk about feelings

 C. Several times a day

10. How do you handle a break-up?

 A. Move on D. I try to figure out what went wrong

 B. I keep myself occupied E. I cry and pig out on junk food while watching too much TV

 C. I listen to sappy break-up music and reminisce

Score Guide

1. A=1, B=2, C=3, D=4, E=5 **2.** A=2, B=1, C=5, D=4, E=3 **3.** A=1, B=4, C=2, D=3, E=5

4. A=4, B=1, C=2, D=3, E=5 **5.** A=5, B=4, C=1, D=3, E=2 **6.** A=2, B=3, C=1, D=4, E=5

7. A=4, B=1, C=2, D=5, E=3 **8.** A=3, B=2, C=1, D=4, E=5 **9.** A=4, B=3, C=5, D=2, E=1

10. A=1, B=2, C=4, D=3, E=5

Your Total Score _____

Results

10-17 Not affectionate

You could use some immediate attention to your softer side. Let your guard down and allow yourself to give and receive love. Affection isn't just for relationships. Your family and friends could use a little TLC from you as well.

18-25 Affection numb

You have the potential to be affectionate but choose not to. You were either really hurt by someone you care about, or are too shy to give into your affectionate side. Let go and hand out some hugs today.

26-33 Mildly affectionate

You have some affectionate tendencies but usually reserve them for private moments. You worry about what other people think and often act too reserved to let loose. You're attracted to affectionate people but don't reciprocate as much as you really want to.

34-41 Affection perfection

You love to shower people with affection, but you don't overdo it. You love expressing how you feel and your relationships are always filled with happiness and positivity.

42-50 Extremely affectionate

You are very affectionate and expressive. You can sometimes make people uncomfortable, but it is not your intention. Just make sure you save your affection for those who appreciate it.

How affectionate are you?

WHAT DECADE ARE YOU FROM?

Do you often feel you were born in the wrong generation? Maybe you were! It's time to find when your soul was born.

1. What fashion statement do you love?
 - A. Psychedelic prints
 - B. Pinstripe suits and fringe
 - C. Denim jackets
 - D. Poodle skirts or leather jackets
 - E. Bell bottoms

2. Which invention is your favorite?
 - A. Personal computer
 - B. 3-D video game
 - C. Hand held calculator
 - D. Credit card
 - E. TV

3. Which historical event was most important to you?
 - A. Women are granted the "right to vote" in the US
 - B. Cigarettes are reported to cause lung cancer
 - C. First American woman goes into space
 - D. Beatles break up
 - E. Kennedy is elected youngest President ever

4. What celebrity do you most admire?
 - A. Molly Ringwald
 - B. Burt Reynolds
 - C. Paul Newman
 - D. Grace Kelly
 - E. Josephine Baker

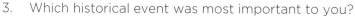

5. Which movie is your favorite?
 - A. A Streetcar Named Desire
 - B. Phantom of the Opera
 - C. Sound of Music
 - D. Breakfast Club
 - E. Star Wars

6. What music genre do you love the best?
 A. Pop or new wave
 B. Disco
 C. Folk
 D. Rockabilly
 E. Jazz

7. What profession do you admire?
 A. Soldier or pilot
 B. Computer technology
 C. Lawyers
 D. Financial industry
 E. Musician or performer

8. What classic car is your favorite?
 A. Honda CRX
 B. Dodge Challenger
 C. Ford Model T
 D. Alfa Romeo
 E. Corvette Stingray

9. What musician do you admire most?
 A. The Rolling Stones
 B. Louis Armstrong
 C. Duran Duran
 D. Elvis
 E. Bee Gees

10. What saying is something you'd say?
 A. For sure
 B. Groovy
 C. Cool it
 D. Burn rubber
 E. You're the cat's meow

Score Guide

1. A=3, B=5, C=1, D=4, E=2 **2.** A=2, B=1, C=3, D=4, E=5 **3.** A=5, B=4, C=1, D=2, E=3
4. A=1, B=2, C=3, D=4, E=5 **5.** A=4, B=5, C=3, D=1, E=2 **6.** A=1, B=3, C=2, D=4, E=5
7. A=4, B=2, C=3, D=1, E=5 **8.** A=1, B=2, C=5, D=4, E=3 **9.** A=3, B=5, C=2, D=4, E=2
10. A=1, B=3, C=2, D=4, E=5

Your Total Score _____

Results

10-17 **80s**
You are totally from the decade of the Rubik's Cube, MTV and the Chicken McNugget. Bunch up those leg warmers!

18-25 **70s**
Can you dig it? You are from the decade of Atari and platform shoes. Light up that disco ball!

26-33 **60s**
You are outta-sight, just like sugar-free soda, The Beatles and the Ford Mustang.

34-41 **50s**
You are a blast from the past, but so is Elvis, so all is well.

42-50 **20s**
You're swell and all that jazz. Where did all the gangsters and flappers go?

WHAT DECADE ARE YOU FROM?

What BREAKFAST food are you?

You are what you eat, but do you eat what you are? Time to find out.

1. What is the most accurate description of you when your alarm goes off?
 A. Snooze. Snooze. Snooze. Oh alright.
 B. Who needs an alarm? My natural clock has me up before dawn.
 C. Good morning, sunshine.
 D. I'm up, but I wouldn't say I'm "awake".
 E. That thing can ring all it wants, I'm not moving.

2. What's your preferred caffeinated beverage?
 A. I don't need caffeine. I'm high on life.
 B. An energy drink
 C. Espresso
 D. Tea or regular coffee
 E. Caramel macchiato

3. In the morning, would you rather:
 A. Read in bed all morning
 B. Go for a run before I start my day
 C. Watch morning shows in my PJs
 D. Meditate for ten minutes
 E. Read the paper at the table

4. What does your typical weekend look like?
 A. Recovering from Friday night
 B. Catching up on stuff around the house
 C. Catch a yoga class and do some shopping
 D. Plans with friends and family
 E. Skydiving, maybe? You never know what can happen.

5. You won a free vacation! Where are you going?
 A. The Grand Canyon
 B. Morocco
 C. Dubai
 D. Disney World
 E. Vermont

6. How do you get around on a day-to-day basis?

 A. Bike or walk as much as possible.
 B. Public transportation
 C. I ride a Vespa
 D. I drive, of course
 E. Going places isn't my thing

7. What's in your fridge?

 A. Ketchup and milk
 B. Frozen pizza and chicken nuggets
 C. Cookie dough
 D. Bag salad
 E. Almond milk and fresh produce

8. You're ordering take-out. Which menu do you grab?

 A. Sushi
 B. Pizza
 C. Chinese
 D. Mexican
 E. Sandwiches

9. How punctual are you?

 A. On-time is 5 minutes late.
 B. I'm always on time.
 C. I make a fashionable entrance
 D. If I'm not 10 minutes late, people look at me funny
 E. What is time, really?

10. Which one of these describes your floors?

 A. I haven't seen them in a while. I'm sure they're still there, though.
 B. Clean swept
 C. A bit of dirt never hurt anyone.
 D. You could eat off of them at a moment's notice.
 E. 5-second rule!

Score Guide

1. A=4, B=1, C=2, D=3, E=5 **2.** A=1, B=5, C=2, D=3, E=4 **3.** A=3, B=1, C=5, D=2, E=4

4. A=5, B=2, C=1, D=4, E=3 **5.** A=4, B=3, C=1, D=5, E=2 **6.** A=1, B=2, C=3, D=4, E=5

7. A=4, B=3, C=5, D=2, E=1 **8.** A=1, B=5, C=4, D=3, E=2 **9.** A=2, B=1, C=3, D=4, E=5

10. A=5, B=2, C=3, D=1, E=4

Your Total Score _____

Results

10-17 Fruit smoothie

You are lean, efficient, and green. Portable goodness to fuel a productive day.

18-25 Bran muffin

You are reliable and healthy, if a little lacking in the excitement department. You are not very adventurous, and you're fine with that. Who would be a hare when you can be a tortoise?

26-33 Omelet

You are nutritious but zesty. Life is about versatility and energy, always with a little sprinkle of cheese.

34-41 The works

We're talking pancakes, bacon, eggs, grits and a biscuit—and don't skimp on the butter. You're hearty and all about fulfillment. Life is meant to be lived!

42-50 A doughnut

Who wants to be a banana when we live in a world that contains frosting? You're delicious and gratifying, and woe to those who try to change you.

What BREAKFAST food are you?

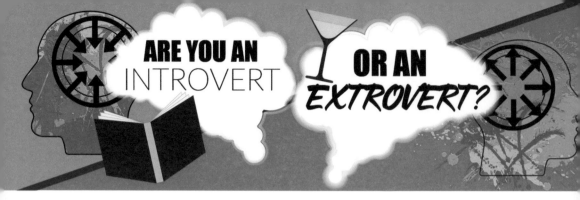

ARE YOU AN INTROVERT OR AN EXTROVERT?

Introversion and extraversion are often misunderstood. "Introvert" is often mistaken for shy, or for not liking people, while extraversion is seen as gregariousness, the life of the party. True, they each have an effect on "people skills", but they actually have more to do with how you work out problems, how you recharge your personal batteries, and what kinds of situations are best suited to your personality.

1. When I'm at a party, you'll find me:

 A. Engaging with one or two people at a time in a quieter area.

 B. In the middle of the room in a large circle of people with all eyes on me.

 C. In a corner just watching and listening.

 D. In a crowded central area enjoying the energy but not the center of attention.

2. When I'm invited to a gathering, I plan to:

 A. Arrive early before it gets too crowded, greet the hosts, and head out in an hour or less.

 B. Stay for most of the night but leave when I get tired.

 C. Set a timer on my phone and make myself stay until it goes off about halfway through the night.

 D. Be the last one to leave.

3. After work, I like to:

 A. Meet up with friends or coworkers at a local hangout before I head home.

 B. Go straight home and change into pajamas. I'm in for the night.

 C. Go home and relax for a bit, then head out for dinner with a friend or a date.

 D. Invite a friend or neighbor to a home cooked meal at my place.

4. At work, I prefer to:

 A. Work independently and solve problems by myself.

 B. Collaborate with a big team all day.

 C. Brainstorm on my own and bring my fully formed ideas to the group.

 D. Bounce ideas off my coworkers.

5. When I'm home alone, I like to:

 A. Text with friends and family, read or watch TV.

 B. Plan a gathering or trip with my favorite people.

 C. This does not compute. I'm never home alone.

 D. Read, listen to music, watch a movie, you name it.

6. My ideal vacation would be:

A. A big cruise where I can bring friends but also meet new people.

B. A quiet B&B in the countryside.

C. Exploring a foreign country with a travel companion.

D. A luxurious resort where my friends and I can relax on the beach.

7. My friend group consists of:

A. An always growing group of acquaintances and lots of close friends.

B. A pretty good number of close acquaintances and a core group of best friends.

C. A small, close-knit group that doesn't vary much.

D. A lot of acquaintances, most of whom I know well and who know me.

8. When I'm hosting at home, I like to:

A. I don't host at home. Like ever.

B. Invite everyone I know and tell them to bring a friend. The more, the merrier!

C. Invite a small, intimate group so we can really talk.

D. Invite as many people as can comfortably fit in my home, turn on some music and create a lively atmosphere.

9. When I have a problem, I confront it by:

A. Talking to a few trusted people about it.

B. Working it out for myself through analysis and introspection.

C. Seeking advice from as many people as will listen.

D. Calling my friends and see what they think.

10. People who know me think I'm:

A. Full of energy and fun to be around.

B. Great to talk to.

C. Friendly and outgoing.

D. Hard to get to know at first.

Score Guide

1. A = 2, B = 4, C = 1, D = 3 **2.** A = 1, B = 3, C = 2, D = 4 **3.** A = 4, B = 1, C = 3, D = 2
4. A = 1, B = 4, C = 2, D = 3 **5.** A = 2, B = 3, C = 4, D = 1 **6.** A = 4, B = 1, C = 3, D = 2
7. A = 4, B = 2, C = 1, D = 3 **8.** A = 1, B = 4, C = 2, D = 3 **9.** A = 3, B = 1, C = 4, D = 3
10. A = 4, B = 2, C = 3, D = 1

Your Total Score _____

Results

10-15 Lovable Loner

You don't hate people, exactly, but they exhaust you, especially in large groups. People may think you're a wallflower or socially awkward. You recharge your batteries in solitude and prefer to spend your time reading, pondering, and only occasionally socializing. When you do socialize, you're more of a listener than a talker. You are capable of deep, lasting, rewarding friendships. You are full of great ideas and are most productive when you work from home.

16-23 Introspective Individual

You don't like big crowds, but you can cope if you have to. People come to you for your advice often. When you hang out with friends, you prefer a quiet restaurant or a movie. When you're invited to gatherings, you only say yes about half the time and make an excuse for the rest. You have a hard time making small talk. You like people watching, going alone to coffee shops or being alone in a crowd.

24-31 Leader of the Pack

You're quite comfortable with people and make new friends easily. You're okay on your own sometimes, but you get invited out a lot and that's fine by you. Chances are, if you plan a nice weekend at home, you'll usually end up calling a friend to meet up. You work well with others, and though you have some cool ideas of your own, the act of brainstorming with a team is exciting and rewarding, too. You have lots of friends on social media and they tag you a lot.

32-40 Extra, Extra Extravert

You thrive in a loud crowd and are a great teammate. You're at your best when you're the center of attention, under pressure, or presenting at a meeting. Being alone is boring. You throw parties regularly for fun, made-up occasions and your friends always have a great time. The best ideas come about when you're working on them with others on a big white board. You usually set the tone for meetings, parties and vacations and people follow you because you are magnetic.

Are you a U.S. HISTORY buff?

We all learned these facts when we were kids, but how well did you retain the knowledge of our country's early years, and how well-rounded is your knowledge?

1. When was the first U.S. settlement established?
 A. 1776
 B. 1607
 C. 1492
 D. 1620

 1492

2. What famous orator, author and activist is famous for saying, "If there is no struggle, there is no progress"?
 A. Martin Luther King, Jr.
 B. Abraham Lincoln
 C. Frederick Douglass
 D. George Washington

3. Who was our opponent in the Battle of Yorktown?
 A. Spain
 B. The Confederate army
 C. England
 D. Germany

4. Who of the following was never a U.S. President?
 A. Gerald Ford
 B. Warren Harding
 C. Alexander Hamilton
 D. Chester Arthur

5. What happened on July 4, 1776?
 A. The Declaration of Independence was signed.
 B. The establishment of Jamestown
 C. The Boston tea party
 D. The Articles of Confederation were signed.

6. What Native American teenager guided Lewis and Clark through the Louisiana Purchase?
 A. Pocahontas
 B. Jane Johnston Schoolcraft
 C. Zitkala-Sa
 D. Sacagawea

7. Which state was the first one ratified?
 A. Massachusetts
 C. California
 B. Pennsylvania
 D. Delaware

8. What former slave became an abolitionist and Union Army spy?
 A. Frederick Douglass
 C. Nat Turner
 B. Harriet Tubman
 D. Frances Harper

9. What Native American chief led the Sioux tribes in the Battle of Little Big Horn?
 A. Sitting Bull
 C. Geronimo
 B. Red Cloud
 D. John Ross

10. What famous Civil War nurse founded the American Red Cross?
 A. Amelia Earhart
 C. Clara Barton
 B. Annie Oakley
 D. Dorothea Dix

11. Who of the following was not a First Lady?
 A. Betsy Ross
 C. Mary Todd Lincoln
 B. Letitia Christian Tyler
 D. Harriet Lane

12. Which President purchased the Louisiana Territory from France?
 A. Monroe
 C. Taft
 B. Madison
 D. Jefferson

Score Guide

1. A=0, B=5, C=0, D=0 **2.** A=0, B=0, C=5, D=0 **3.** A=0, B=0, C=5, D=0

4. A=0, B=0, C=5, D=0 **5.** A=5, B=0, C=0, D=0 **6.** A=0, B=0, C=0, D=5

7. A=0, B=0, C=0, D=5 **8.** A=0, B=5, C=0, D=0 **9.** A=5, B=0, C=0, D=0

10. A=0, B=0, C=5, D=0 **11.** A=5, B=0, C=0, D=0 **12.** A=0, B=0, C=0, D=5

Your Total Score _____

Results

0-15 **Back to basics**

Congratulations, you have some learning to do. There are plenty of films, books, and even musicals out there waiting to expand your knowledge, so enjoy and find your inner history nerd. Your friends and family will be so impressed with the new references you drop at the dinner table.

20-35 **Your smarty pants need ironing**

You know enough to impress your friends and acquaintances at parties, and you don't scratch your head when someone mentions a lesser-known president, but you may want to pick up a book about the eras that interest you and go into more depth.

40-50 **Founders fanatic**

Well done! You are a fountain of knowledge about our country's foundation. You may even be able to recite some of the Gettysburg Address. To earn the A+, enrich your fantastic smarts with people and events outside of dates, presidents and battles.

55-60 **Life of the nerd party**

Gold star for you! Your knowledge is not only flawless, it's well-rounded and diverse. You have taken the time to learn not just the text book chapters, but the figures who sometimes get lost in the margins.

If you could describe your personality in a major holiday, which one would it be? Will the answer surprise you, or are you pretty sure you're New Year's on two legs? Let's find out!

1. What is your favorite color?
 - A. Black
 - B. Green
 - C. Pink
 - D. Gold
 - E. Orange

2. What does your sweet tooth prefer?
 - A. Chocolate fondue
 - B. Sugar cookies
 - C. Candy corn
 - D. Pumpkin pie
 - E. Champagne strawberries

3. What is your favorite party decoration?
 - A. Confetti
 - B. Colorful lights
 - C. Balloons
 - D. Dry ice
 - E. Fresh flowers

4. What do you love most about holidays?
 - A. A departure from the everyday
 - B. Spending time with family
 - C. Spending time with a special person
 - D. Dressing up and going out
 - E. Sharing gifts

5. What is your favorite way to change things up in the non-holiday season?
 - A. Throw an impromptu bash
 - B. Volunteering
 - C. Shopping spree
 - D. Cosplay
 - E. A romantic getaway

6. What is your favorite month?
 A. October
 B. December
 C. February
 D. January
 E. November

7. What tradition do you love most?
 A. Cooking
 B. Candlelight dinners
 C. Caroling
 D. Dancing
 E. Trick or treating

8. Pick a personality trait that best describes you.
 A. Creative
 B. Generous
 C. Loving
 D. Confident
 E. Forgiving

9. What is most important to you?
 A. Candy
 B. World peace
 C. Love
 D. Achieving goals
 E. Gratitude

10. Choose your favorite city?
 A. Transylvania
 B. Zurich
 C. Paris
 D. New York City
 E. Plymouth

THANKSGIVING

Score Guide

1. A=1, B=2, C=3, D=4, E=5 **2.** A=3, B=2, C=1, D=5, E=4 **3.** A=4, B=2, C=3, D=1, E=5
4. A=1, B=5, C=3, D=4, E=2 **5.** A=4, B=5, C=2, D=1, E=3 **6.** A=1, B=2, C=3, D=4, E=5
7. A=5, B=3, C=2, D=4, E=1 **8.** A=1, B=2, C=3, D=4, E=5 **9.** A=1, B=2, C=3, D=4, E=5
10. A=1, B=2, C=3, D=4, E=5

Your Total Score _____

Results

10-17 Halloween

You are creative and expressive. You like to dress up as and impersonate personalities you admire. You are playful and fun and have a serious sweet tooth. You are happy carving a pumpkin or wearing a scary mask. Embrace your inner prankster.

18-25 Christmas

You are caring and giving and always think of other people. You love the sounds and the spirit of the season. You enjoy everything about this holiday from shopping to gatherings. You are happy decorating a gingerbread house or a Christmas tree.

26-33 Valentine's Day

You are sensitive and sweet and love the togetherness of the holiday. You are happy holding hands and spending time with that special person. You enjoy poetry and long walks along the beach, and you are drawn to the romance of the season.

34-41 New Year's Eve

You are hopeful and driven and you love to set new goals for yourself. You enjoy parties and socializing, but more than that you are excited with all the New Year will have to offer.

42-50 Thanksgiving

You are thankful and appreciative for all that you have. You love cooking and eating and spending time with family. You feel reflective, sentimental and a bit nostalgic. Fall is your favorite season.

What Ice Cream flavor are you?

No matter what your preferences, ice cream is for people who love to treat themselves. If you were an indulgence in a little frozen carton, what flavor would you be?

1. You have plans with friends. What would you rather do?
 A. Stay in and order take-out
 B. Go out for cheeseburgers or pizza
 C. See a movie or start a book club
 D. Go to a play, museum or art show
 E. Explore the city on foot. Or laser tag!

2. Choose your favorite punctuation mark.
 A. ;
 B. ,
 C. ?
 D. !
 E. &

3. Choose your favorite electronic device (whether you own one or not).
 A. Smart home device
 B. Smart watch
 C. Smart phone
 D. Tablet
 E. Fitbit

4. Choose your favorite morning activity.
 A. Sleeping late
 B. Yoga
 C. A sunrise run or walk
 D. Writing in a journal
 E. Reading or watching TV

5. How do you like to observe your birthday?
 A. Throw a birthday party
 B. Do something on my bucket list
 C. Cake
 D. Reflect on the past year and the year to come
 E. Buy myself a present

6. What is your favorite meal?
 A. Breakfast
 B. Brunch
 C. Dessert
 D. Picnic
 E. Smoothie

7. What do you like to do online?
 A. Read blogs
 B. Stream videos, shows and movies
 C. Surf social media
 D. Check email
 E. Browse shopping sites

8. What is your go-to garment?
 A. A scarf or cardigan
 B. Jeans
 C. T-shirts from concerts and events I've attended (or featuring funny phrases)
 D. Button down collared shirts, from fancy to flannel
 E. A hoodie or sweater

9. How do you spend the holidays?
 A. Baking
 B. Attending parties
 C. Shopping and decorating
 D. Visiting family
 E. Spreading the holiday spirit

10. Which word means the most to you?
 A. Adventure
 B. Warm
 C. New
 D. Earth
 E. True

Score Guide

1. A=1, B=2, C=3, D=4, E=5 **2.** A=4, B=1, C=2, D=5, E=3 **3.** A=2, B=4, C=1, D=3, E=5

4. A=2, B=4, C=5, D=4, E=1 **5.** A=3, B=5, C=2, D=4, E=1 **6.** A=1, B=3, C=2, D=5, E=4

7. A=4, B=2, C=5, D=1, E=3 **8.** A=4, B=1, C=5, D=3, E=2 **9.** A=2, B=5, C=3, D=1, E=4

10. A=5, B=2, C=3, D=4, E=1

Your Total Score _____

Results

10-17 Vanilla

You proudly embrace the old-fashioned. Some may think you plain, but like a white tee shirt, a strong basic is the most versatile. With a few additions, you can become a sundae, a milkshake, a cookie sandwich, or anything imaginable.

18-25 Double Chocolate Fudge

You are all about indulgence. You are the "life is uncertain; eat dessert first" type, and you don't mess around when it comes to sweets. You would rather have a smaller amount of the real thing than switch to low-fat.

26-33 Sea Salt Caramel

Variety is the spice of life. You have a sweet tooth, but you are a bit more complex in your tastes. You like chocolate alright, but you don't necessarily need it in your desserts and you prefer to mix it up with something salty.

34-41 Green Tea

You are earthy and spiritual. You like a sweet treat as much as the next person, but you prefer something different from the everyday. You pay attention to subtleties and undertones and appreciate quiet moments of joy.

42-50 Rainbow Sherbert

You are adventurous and active, and you love to try new things. You don't like to be weighed down by heavy meals or rich desserts because you don't like to sit still for very long. You're not much of a chocolate person, but sugary treats are fine and dandy.

What Ice Cream flavor are you?

ARE YOU A HUMAN CALCULATOR?

$x + 67^2 = y$
$\sin + 56 = \cos$

Are you a math whiz, or do you need a calculator to figure out the tip at a restaurant? Put away all devices and use only your own brain to answer these questions. You may surprise yourself!

1. 32 – 8 = ?
 A. 26
 B. 28
 C. 24
 E. 27

2. 12 x 15 = ?
 A. 180
 B. 200
 C. 150
 D. 140

3. 31 + 28 = ?
 A. 61
 B. 59
 C. 69
 D. 57

4. 140 / 7 = ?
 A. 40
 B. 12
 C. 20
 D. 14

5. Which of the following numbers does NOT divide evenly into 120?
 A. 12
 B. 40
 D. 6
 E. 9

6. Which of the following numbers DOES divide evenly into 380?
 A. 19
 B. 13
 C. 12
 E. 16

7. 395 + 537 = ?
 A. 883
 B. 962
 C. 932
 D. 891

8. What is 20% of $35.00?
 A. $8.25
 B. $7
 C. $7.50
 D. $6.50

9. 346 / 1 = ?
 A. 346
 B. 173
 C. 1
 D. 0

10. 346 x 0 = ?
 A. 346
 B. 173
 C. 1
 D. 0

$x + 67^2 = y$
$\sin + 56 = \cos$

Your Total Score _____

Results

0-15 If I only had a calculator

Ok, so numbers aren't your thing. Just remember, to leave a 20% tip, leave $2 for every $10 on the bill.

20-30 Functional mathematician

You may have to double check yourself now and then, and the more complex stuff is a challenge, but you can be trusted to leave an accurate tip and balance a checkbook.

35-40 Present Day Math Master

When people ask in high school, "How will I ever use this knowledge?", you are the answer. When you go out to dinner with friends, you are the one who works out who owes what, and no one questions you.

ARE YOU AN EXPERT S P E L L E R ?

Febuary
Frebuary
February
Ferburary

Crocodile
Crockodile
Crockdile
Corkodile

Dissapear
Dissappear
Disappear
Disapare

Are you the belle of the spelling bee, or the first one eliminated? A word ninja or a werd ninga? Can you switch off autocorrect with confidence, or are you lost without it? Using only the power of your own brain, find the right and wrong spellings below.

1. Which of the following words is spelled correctly?
 A. Eccentric C. Ecsentric
 B. Exentric D. Excentric

2. Which of the following words is spelled correctly?
 A. Forfit C. Forefit
 B. Forfeit D. Forfiet

3. Which of the following words is spelled incorrectly?
 A. Entrepreneur C. Persevear
 B. Sentence D. Onomatopoeia

4. Which of the following words is spelled incorrectly?
 A. Orangutan C. Salimander
 B. Ostrich D. Emu

Arguement
Argument
Arrghument
Argrument

5. Which of the following is not a word?
 A. Bough C. Boe
 B. Bow D. Bout

6. Which of the following words means "a long letter"?
 A. Epistle C. Episode
 B. Epitaph D. Epithet

7. Which of the following words is spelled correctly?
 A. Sive C. Sieve
 B. Siv D. Seive

8. Which of the following words is spelled incorrectly?
 A. Throughout C. Enough
 B. Bougher D. Ought

Febuary
Frebuary
February
Ferburary

9. Which of the following words is an animal?
 A. Cappuccino C. Capitulate
 B. Capuchin D. Capricorn

10. Which of the following is a caffeinated beverage?
 A. Cappuccino C. Capitulate
 B. Capuchin D. Capricorn

Score Guide

1. A=4, B=2, C=3, D=1 **2.** A=2, B=4, C=1, D=3 **3.** A=2, B=1, C=4, D=3

4. A=2, B=3, C=4, D=1 **5.** A=3, B=1, C=4, D=2 **6.** A=4, B=2, C=1, D=3

7. A=2, B=1, C=4, D=3 **8.** A=2, B=4, C=1, D=3 **9.** A=1, B=4, C=3, D=2

10. A=4, B=3, C=2, D=1

Your Total Score _____

Results

10-17 Hope you're good at math...
... Because spelling isn't your strong suit.

18-25 Stick with spell check
You did admirably, but have someone proofread your work emails.

26-33 Honor roll bumper sticker
You're not an Olympian speller, but you don't need to panic when writing in permanent ink.

34-40 Word guru
Your brain is a wonder to behold.

Conscious
Conshuss
Conshous
Conscoush

ARE YOU AN EXPERT S P E L L E R ?

Febuary
Frebuary
February
Ferburary

Crocodile
Crockodile
Crockdile
Corkodile

Dissapear
Dissappear
Disappear
Disapare

ARE YOU FLUENT IN TEXT?

If you were to text with a teenager, would they LOL at you, or would they be all OMG? Translate the following text abbreviations to find out.

1. BRBB
 A. Been round, been back
 B. Be right back, babe
 C. Be right, baby
 D. Bring ribs—baby back

2. ROTFL
 A. Right on the front lines
 B. Running off to Florida
 C. Rolling otters tickle for laughs
 D. Rolling on the floor laughing

3. BFFLNMW
 A. Best friends for life no matter what
 B. Best friends for life, not my wife
 C. You've got to be joking with this one.
 D. Better find fun little natural markets this weekend

4. YOLO
 A. You only love once
 B. You locked out?
 C. You only live once
 D. Yoyo love

5. DKDC
 A. Don't krinkle dad's coat
 B. Don't know don't care
 C. Don't kick down cows
 D. Do kind deeds for charity

6. CURLO
 A. Curled up reading alone
 C. See you around like a doughnut
 B. See you running like an Olympian
 D. Can you remember last night?

7. BL
 A. Belly laugh
 C. Busted lung
 B. Badly
 D. Bad love

8. SSDD
 A. So sad, don't dare
 C. Same story different dude
 B. Some stuff didn't do
 D. Same stuff different day

9. HRU
 A. Hold right up
 C. Holy rotten universe
 B. How are you?
 D. Honor roll university

10. YGTR
 A. You've got that right
 C. You're going to regret
 B. You've got to read
 D. You get two redos

Score Guide

1. A=0, B=5, C=0, D=0 **2.** A=0, B=0, C=0, D=5 **3.** A=5, B=0, C=0, D=0
4. A=0, B=0, C=5, D=0 **5.** A=0, B=5, C=0, D=0 **6.** A=0, B=0, C=5, D=0
7. A=5, B=0, C=0, D=0 **8.** A=0, B=0, C=0, D=5 **9.** A=0, B=5, C=0, D=0
10. A=5, B=0, C=0, D=5

Your Total Score _____

Results

10-17 FGYI

What does that mean? Maybe something, maybe nothing. Unfortunately, you are not hip enough to know either way. Assume it is a compliment.

18-25 DTS

Don't think so. You know the basics, but you'd better stick to real words for a while longer.

26-33 DQMOT

Don't quote me on this. You're not completely teen-savvy, but you're no slouch with the hip lingo.

34-40 YWHOL

No explanation needed.

ARE YOU FLUENT IN TEXT?

Being first means being a trailblazer. Making history. It paves the way for all the seconds, thirds, and beyond. Many of the most impactful firsts started from nothing and worked their way to greatness in their fields. Be prepared to test the best parts of yourself and get inspired to greatness!

1. Are you male or female?
 A. Male
 B. Female

2. What was your favorite subject in school?
 A. Music
 B. English
 C. U.S. History
 D. Gym
 E. Science
 F. Women's History

3. What would you want to be remembered for?
 A. Reaching the stars
 B. Opening doors for people like me
 C. My talent and confidence
 D. My creativity and generosity
 E. Fighting for freedom
 F. Engaging others with my skills and personality

4. What do you like to read?
 A. The Constitution
 B. I'm more of a magazine person
 C. Fiction. I just love stories
 D. Biographies of groundbreaking women
 E. Books that make me marvel at the universe
 F. The Bible

5. When you go to Disney World, what do you like to do?
 A. Ride rollercoasters
 B. Hall of Presidents
 C. Space Mountain
 D. Dress up like a princess
 E. Everything! I love entertainment
 F. Avoid the crowds

6. How would you describe your social personality?

 A. I am introverted and enjoy time alone

 B. I am great with people and need a little time for reflection now and then

 C. I love a crowd and feed off their energy

 D. I prefer small groups of people I know and trust

 E. I work alone but I play in groups

7. When someone offends you, how do you react?

 A. I confront them with strength and wisdom

 B. I tell them off and demand respect

 C. I am not easily offended and don't care what anyone thinks of me

8. Why does being first matter to you?

 A. To show people they can do anything they set their minds to.

 B. To create something bigger than my-self that lasts beyond my lifetime

 C. The journey and knowledge you gain is more important than being first

 D. I hadn't thought of it because I never meant to be first

 E. Because it earns me the respect I de-serve

 F. Being first shows I have worked hard to become the best

9. What inspires you to do your best?

 A. Music that moves me

 B. My teammates

 C. The greater good

 D. My imagination

 E. Being told I can't do something

 F. The unknown

10. Who do you look up to most?

 A. Rosa Parks

 B. Jane Austen

 C. Alexander Hamilton

 D. Albert Einstein

 E. Tina Turner

 F. Michael Phelps

Score Guide

1. A=0, B=5

2. A=4, B=6, C=1, D=3, E=2, F=5

3. A=2, B=5, C=4, D=6, E=1, F=3

4. A=1, B=3, C=6, D=5, E=2, F=4

5. A=5, B=1, C=2, D=4, E=3, F=6

6. A=6, B=1, C=3, D=2, E=5

7. A=1, B=3, C=5

8. A=5, B=1, C=2, D=6, E=4, F=3

9. A=4, B=3, C=1, D=6, E=5, F=2

10. A=5, B=6, C=1, D=2, E=4, F=3

Your Total Score _____

Results

10-17 **You are George Washington**

A gentleman and a general, you are the first President of the United States. Washington and his comrades set the standard for what it means to be a statesman. His charisma and experience earned him unanimous support at the Constitutional Convention. You have a political, detail-oriented mind, but you take counsel seriously when it comes from people you respect.

18-26 **You are Neil Armstrong**

When you hear the word "first," the first person to pop into anyone's mind is the first man to walk on the moon. While his reputation flies high, Armstrong was all about knowledge and science. He began as a marine before he went on to become a pilot, astronaut, professor, and recipient of the Presidential Medal of Honor. You are daring and curious, and you encourage greatness in others. But while you strive for achievement, you are humble and know how small you are in the universe.

27-35 **You are Pelé**

Edson Arantes do Nascimento, known as Pelé, was a World Cup Brazilian soccer player and the first footballer to score 1,000 goals in competition. Well loved by his fans and his team mates, Pelé was known for his flair and played professionally for two decades. You are an athlete and are in it for the love of the game. You work hard to be your best, but you also lift up your teammates as well.

36-43 **You are Aretha Franklin**

Congratulations, you are the queen of soul. With a career total of 18 Grammies won, Franklin was the first woman to be inducted into the Rock 'n' Roll Hall of Fame. She also has a star on the Hollywood Walk of Fame, and her voice was declared a "natural resource" in Michigan. You love music and have no problem singing out loud. You are confident, demand R-E-S-P-E-C-T and don't suffer a chain of fools.

44-52 **You are Bessie Coleman**

Inspired by stories of flyers during World War I, Bessie Coleman, also known as "Queen Bess," became the first African American and the first Native American woman to hold a pilot license. Like Coleman, you love flying high and breaking boundaries. You are not afraid of hard work and big risks if it means reaching your goal.

53-60 **You are J.K. Rowling**

J.K. Rowling, author of the Harry Potter series, is the first writer to become a billionaire. A well-known introvert and generous soul, you also double up on firsts, because Rowling is the first billionaire to lose their billionaire status due to philanthropic giving. You are creative but quiet. You give to others as much as you can because you know what it's like to do without, but you don't make a big announcement about it.

We all have one, or several. They can be whims, or they can define how people see you and shape your relationships, and even your health. What are your bad habits, and how do they affect your life?

1. Choose one bad habit you do often:
 A. Nail biting
 B. Smoking
 C. Using curse words
 D. Chew food with mouth open
 E. More than one listed above

2. How often do people bring one of your bad habits to your attention?
 A. Never
 B. Often
 C. Sometimes
 D. At least once a week
 E. Daily

3. Do you ever annoy yourself with your bad habit?
 A. No
 B. Maybe once or twice
 C. Occasionally
 D. Only when other people mention it
 E. Yes

4. How do you feel about your bad habit(s)?
 A. I need to try and get better
 B. It relaxes me
 C. There are worse habits to have
 D. It's probably annoying
 E. I don't think it's that bad

5. Which of these activities do you love most?
 A. Swimming or skating
 B. Watching TV or playing video games
 C. Anything sports related
 D. Hanging out with friends at a bar
 E. All of the above

6. How is your hygiene?
 A. Normal
 B. I've been known to skip a shower or two
 C. Super clean, bordering on neat freak
 D. Average
 E. I can get dirty with the best of them but clean up real nice

7. Have you ever had an argument with someone about your habit/s?
 A. Never
 B. Often
 C. Occasionally
 D. Yes
 E. It has been the subject of bad arguments

8. Has your bad habit ever cost you a friend or relationship?
 A. Yes
 B. No
 C. More than once
 D. I hope not
 E. If it did, then they weren't a good friend

9. Who gives you the most grief about your habit?
 A. My parents
 B. My romantic relationships
 C. The better question is, who doesn't?
 D. My doctor
 E. No one in particular

10. Do you want to quit your bad habit?
 A. Nope. I am who I am.
 B. I've thought about it a lot, but it would be really hard.
 C. I don't consider it bad, so no.
 D. I will if it bothers too many people.
 E. I could if I tried, but it's pretty harmless.

Score Guide

1. A=1, B=2, C=3, D=4, E=5 **2.** A=1, B=2, C=3, D=4, E=5 **3.** A=3, B=1, C=2, D=4, E=5

4. A=4, B=2, C=3, D=5, E=1 **5.** A=1, B=4, C=3, D=2, E=5 **6.** A=3, B=4, C=1, D=2, E=5

7. A=1, B=2, C=3, D=4, E=5 **8.** A=2, B=1, C=5, D=4, E=3 **9.** A=3, B=4, C=5, D=2, E=1

10. A=5, B=2, C=3, D=4, E=1

Your Total Score _____

Results

10-17 Not that bad

If all you do is bite your nails, then you're in pretty decent shape, habits-wise. Your habit bothers you more than anyone else, and is a lesser evil compared to other bad habits. You should be careful and make sure your hands are clean before you take another trip to the nail buffet.

18-25 Pretty Bad

Your habit affects anyone around you, and especially yourself. It is life altering and can lead to serious health issues. The act of smoking calms you down, but it has caused you to lose potential relationships and left you feeling a bit alienated.

26-33 Common

Your bad habit is pretty common, though it can be both funny and offensive. If you use your profanity as a weapon, it can be destructive and aggravating. It doesn't bother you nor your close friends. It does bother some, but you don't care.

34-41 Annoying

Your bad habit is super annoying and people hate being around you when you eat. Your bad habit is considered gross by many but you often times don't notice. Slow down, enjoy your food and remember to keep your mouth closed while you're chewing. It's pretty simple.

42-50 Multiple offender

You're a bad habit multiple offender. You are fully aware of the toll it takes on your life, and honestly, you don't care. You could eliminate some, but in your mind they go hand and hand. Hopefully you can work it out before you lose more friends or people you care about.

What caffeinated drink are you?

They're all delightful, but which one are you? Are you strong like coffee or bubbly like soda? Are you indulgent or practical?

1. Describe your personality in one word.
 - A. Bold
 - B. Silly
 - C. Mature
 - D. Energetic
 - E. Outgoing

2. What is your favorite winter activity?
 - A. Going to museums
 - B. Throwing parties
 - C. Reading by a warm fire
 - D. Outdoor sports like skiing
 - E. Cuddling and watching movies

3. Pick your favorite baked good?
 - A. Donuts
 - B. Mini muffins
 - C. Biscotti
 - D. Cookies
 - E. Scones

4. How many times a week do you socialize?
 - A. Not often
 - B. Almost every day
 - C. Maybe once
 - D. Two or three
 - E. Depends on my mood

5. Which one appeals to you most?
 - A. Intelligence
 - B. Fun
 - C. Sophistication
 - D. Excitement
 - E. Comforting

6. Pick a rainy day activity.
 A. Watching a good documentary
 B. Video games
 C. Cooking a big meal
 D. Shooting pool
 E. Sleep

7. What's the best thing about your personality?
 A. My sweet personality
 B. My outgoing attitude
 C. My good manners
 D. My sense of humor
 E. My wit

8. How blunt are you?
 A. Very. I have no qualms.
 B. I am only blunt with people I know well
 C. Only when I know I'm right
 D. Not really. I prefer to keep things light.
 E. I'm honest but gentle

9. What is most important to you?
 A. Self-improvement
 B. Being true to myself
 C. Shaping world events and politics
 D. Staying in shape
 E. Friends and family

10. What social media app best describes you?
 A. None. That stuff rots your brain.
 B. Facebook
 C. Pinterest
 D. Twitter
 E. Instagram

Score Guide

1. A=1, B=2, C=3, D=4, E=5 **2.** A=3, B=2, C=1, D=4, E=5 **3.** A=5, B=2, C=1, D=4, E=3

4. A=3, B=2, C=5, D=4, E=1 **5.** A=1, B=2, C=3, D=4, E=5 **6.** A=3, B=4, C=5, D=2, E=1

7. A=5, B=4, C=3, D=2, E=1 **8.** A=1, B=2, C=3, D=4, E=5 **9.** A=1, B=2, C=3, D=4, E=5

10. A=1, B=2, C=3, D=4, E=5

Your Total Score _____

Results

10-17 Coffee

You are bold and strong. You are set in your ways and have an opinion about everything. You are smart and charming, but people sometimes get on your nerves after a while. You like people to know where you stand, and they are free to agree or disagree.

18-25 Soda

You are bubbly and spontaneous. You live life to the fullest and enjoy each day as it comes. It is important to you to be yourself and you pride yourself on being unique. You are creative and colorful but you do have moments of deep thought and reflection.

26-33 Tea

You are sophisticated and refined. You love having conversations and discussing history and current events. You are worldly and enjoy life's little pleasures. Some think you are snobbish, but people who get you enjoy your knowledge.

34-41 Energy Drink

You are high-energy, outgoing, adventurous and very active. You like living on the wild side and trying new activities. You hang around with other like-minded individuals.

42-50 Latte

You are sweet, warm and cuddly. You are generous and loving and make others around you feel cared for. You are well-balanced and prefer to hang out with your significant other more than anyone.

What caffeinated drink are you?

WHAT IS IN YOUR PIRATE'S CHEST?

If you were a pirate and sailed the rugged seas, what would you be on a mission to pilfer and plunder? What would be in your treasure chest?

1. What does "valuable" mean to you?
 - A. Rare and beautiful
 - B. Maximum sparkle factor
 - C. Monetary value
 - D. Irreplaceable and unique
 - E. Luxurious and pure

2. What would be your ship's mascot?
 - A. Raven
 - B. Serpent
 - C. Parrot
 - D. Giant squid
 - E. Shark

3. What emblem would be on your pirate ship's main sail?
 - A. Crossed swords
 - B. Stripes
 - C. Skull and crossbones
 - D. Lightning bolts
 - E. The whole sail would be bright red.

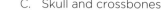

4. What is most important to a pirate captain?
 - A. The ship's crew
 - B. A keen eye on the watch
 - C. Plenty of loot
 - D. A sturdy ship
 - E. Plenty of weapons

5. Which of these would you do as a pirate?
 - A. Drink and spend my fortune
 - B. Attack and invade land to rob treasures
 - C. Find and hoard hidden treasure
 - D. Retire in wealth
 - E. Steal other pirate ships to create a fleet

6. What would be your signature trademark?
 A. Eyepatch
 D. Tattoos
 B. Feathered hat
 E. Scar
 C. Peg leg

7. How would you punish your prisoners?
 A. Keep them in a brig
 D. Torture them with weird gadgets
 B. Stone them
 E. Make them work on the ship
 C. Make them walk the plank

8. Which name would you want as your pirate name?
 A. Captain Black Jack
 D. Captain Blackbeard
 B. Captain Barbossa
 E. Captain Willie
 C. Captain Hook

9. What island would you claim as your own?
 A. England
 D. The Azores
 B. Australia
 E. Sicily
 C. Bermuda

10. What would be the name of your ship?
 A. Dark Voyager
 D. The Pillager
 B. Black Pearl
 E. Davy Jones
 C. Jolly Rodger

Score Guide

1. A=1, B=2, C=3, D=4, E=5 **2.** A=1, B=2, C=3, D=4, E=5 **3.** A=1, B=2, C=3, D=4, E=5
4. A=1, B=2, C=3, D=4, E=5 **5.** A=1, B=2, C=3, D=5, E=4 **6.** A=1, B=2, C=3, D=4, E=5
7. A=1, B=2, C=3, D=4, E=5 **8.** A=1, B=2, C=3, D=4, E=5 **9.** A=1, B=2, C=3, D=4, E=5
10. A=1, B=2, C=3, D=4, E=5

Your Total Score _____

Results

10-17 Paintings and rare works of art

Your treasure chest is filled with a collection of art. You are a pirate with more noble and sophisticated tastes and the finer artistic treasures hold more value for you. You fancy yourself as a pirate that collects expensive, one-of-a-kind pieces that can't be replicated or mass produced.

18-25 Rubies, emeralds, sapphires and diamonds

Your treasure chest is filled with precious gemstones. You love the color and beauty of stones and the high dollar value of diamonds. You love to adorn yourself with your conquests and often use them in your attire to display your wealth.

26-33 Bars of gold and gold coins

Your treasure chest is filled with gold, gold, and gold. You love gold and in your mind, it is the only thing in life of value. From gold coins to bars of gold, you want it all.

34-41 Priceless inventions, heirlooms and antiques

Your treasure chest is filled with family heirlooms and antiques plundered off the rich families you've invaded. You love goblets, jewelry and collectibles that are pricy and unique. You keep them as a reminder of your power and carnage.

42-50 Silver treasures and rare coins

Your treasure chest is filled with silver. You love silver of any kind from serving dishes to jewelry and especially rare coins. You want to surround yourself in everything silver so you can truly feel luxury.

WHAT DO YOUR JEANS SAY ABOUT YOU?

Your jeans are an extension of your personality. They certainly say a lot about you! Your jeans send a message to the world—take this quiz to find out what they're saying.

1. How many pairs of jeans do you own?
 - A. 6 - 8
 - B. 2 - 3
 - C. 4 - 5
 - D. 1
 - E. Too many to count

2. What type of jean is your favorite?
 - A. Bootcut
 - B. Straight leg
 - C. Flare
 - D. Skinny
 - E. I love them all

3. What color do you prefer in jeans?
 - A. Um, blue?
 - B. It's not called "color," it's called "wash," and I can't choose just one.
 - C. Faded blue
 - D. Black denim
 - E. Basic indigo

4. Do you prefer vintage, new or trending jean fashion?
 - A. Depends on the jean
 - B. I've been wearing the same style for years. Does that count as vintage?
 - C. I can't tell the difference
 - D. A little bit of everything
 - E. I'm all about trendy

5. Which word describes what you look for in jeans?
 - A. Durable
 - B. Comfortable
 - C. Fashion forward
 - D. Playful
 - E. Want

6. If you had to pick one denim garment, which would you choose?
 A. Shorts
 B. Cargos
 C. Jacket
 D. It's not the garment, it's the label.
 E. Can I pick two? Double denim is back.

7. Consider the holes in your jeans...
 A. Today's ripped knees are tomorrow's cutoff shorts.
 B. I never wear jeans with holes in them.
 C. Wear and tear is a sign of love.
 D. Only the strategically-placed holes that come with them are acceptable.
 E. I have so many pairs, I can choose how hole-y I'm feeling day by day.

8. When do you wear jeans the most?
 A. When I can find them
 B. School or work
 C. Social events and dates
 D. Hanging with friends or casual events
 E. I can dress them up or dress them down

9. Pick a jean embellishment:
 A. Jewels
 B. I'll take one of each
 C. Patches
 D. Tears or rips
 E. None

10. Would you ever let a friend borrow your jeans?
 A. I only have one pair and I'm wearing them
 B. No way
 C. To my closest friend
 D. If we can exchange jeans
 E. Sure I have plenty

Score Guide

1. A=4, B=2, C=3, D=1, E=5 **2.** A=1, B=2, C=3, D=4, E=5 **3.** A=1, B=5, C=3, D=4, E=2
4. A=3, B=2, C=1, D=5, E=4 **5.** A=2, B=1, C=4, D=3, E=5 **6.** A=1, B=2, C=3, D=4, E=5
7. A=1, B=2, C=3, D=4, E=5 **8.** A=1, B=2, C=3, D=4, E=5 **9.** A=3, B=5, C=1, D=4, E=2
10. A=1, B=2, C=3, D=4, E=5

Your Total Score _____

Results

10-17 Laid back

You take life as it comes, you're not in a hurry and you don't care what fashion is trending. You just want to be happy and do your own thing. You want your clothes to fit your lifestyle and you prefer shorts more than jeans.

18-25 Hard Worker

You're serious about your jeans. They need to be durable, functional and fit nicely. Your jeans are always clean and nicely pressed. You love western jeans, cargo pants or work jeans. You keep to yourself most times but are a very kind person.

26-33 Playful

Your jeans say you're fun, outgoing and chatty. You love hanging out with friends and enjoying the social scene. You are lighthearted and have a great sense of humor. You're random but everyone loves you because of your outgoing personality. You love your jeans and wear them over and over again.

34-41 Stylish

You love the finer things in life, and your jeans are no different. You are very picky about the brand and fit of your jeans. You want the latest trends and won't settle for anything less. You want to look your best at all times, and you care a great deal about others' opinions.

42-50 Shopaholic

It's time for an intervention because you'll buy every pair of jeans you see if you like them. You have an appreciation of clothes, vintage or new. You are friendly and silly and you're the leader in your inner circle. People value your advice and love hanging out with you. You have a bit of the rebel in your but you balance it out.

Are you a MASTER of random TRIVIA?

How would you do at your local trivia night? Would you be the team captain, or the friend who just comes along for the ride? Time to test your trivia chops!

1. What is the only manmade object visible from the moon?
 A. The Great Pyramids
 B. The Great Wall of China
 C. The San Francisco Bridge
 D. Stonehenge

2. What is the largest fish in the ocean?
 A. Giant squid
 B. Blue whale
 C. Whale shark
 D. Lion's mane jellyfish

3. What artist painted a mustache and goatee on the Mona Lisa?
 A. Marcel Duchamp
 B. Salvador Dali
 C. Jackson Pollock
 D. Leonardo DaVinci

4. What is the most popular non-alcoholic drink in the world?
 A. Cola
 B. Lemonade
 C. Milk
 D. Coffee

5. What is the largest planet in the solar system?
 A. Jupiter
 B. Saturn
 C. Venus
 D. Uranus

6. What is the National Anthem of the United States?
 A. God Bless America
 B. The Star Spangled Banner
 C. My Country 'Tis of Thee
 D. You're a Grand Old Flag

7. What word is a famous film, a North African seaport, and Spanish for "white house"?
 A. Carte blanche
 B. Carpe diem
 C. Casablanca
 D. Desperado

8. Who was the first woman to fly across the Atlantic Ocean?
 A. Sally Ride
 B. Marie Curie
 C. Eleanor Roosevelt
 D. Amelia Earhart

9. Who was the first Vice President of the United States?
 A. John Adams
 B. Alexander Hamilton
 C. Thomas Jefferson
 D. Hercules Mulligan

10. What was Mark Twain's real name?
 A. Samuel Jackson
 B. Samuel Clemens
 C. John Smith
 D. Kenneth Adams

Score Guide

1. A=0, B=5, C=0, D=0 **2.** A=0, B=0, C=5, D=0 **3.** A=5, B=0, C=0, D=0
4. A=0, B=0, C=0, D=5 **5.** A=5, B=0, C=0, D=0 **6.** A=0, B=5, C=0, D=0
7. A=0, B=0, C=5, D=0 **8.** A=0, B=0, C=0, D=5 **9.** A=5, B=0, C=0, D=0
10. A=0, B=5, C=0, D=0

Your Total Score _____

Results

0-15 Specialist

You are invited to trivia night to fill a specific knowledge gap. You may not be a master of the random, but you are very knowledgeable about certain areas.

20-35 Trivia team MVP

You got about half of the questions right. You'd be a valuable member of the trivia team.

40-50 Master of all, master of none

Well done! You must do a lot of crossword puzzles and trivia games.

VHAT FLAVOR POTATO CHIP WOULD YOU BE?

Who isn't a little crunchy? But if you were a potato chip, which flavor would you be?

1. Pick your favorite appetizer/side:
 A. Pickles
 B. Jalapeños
 C. Mozzarella sticks
 D. Bread
 E. Calamari

2. Describe your temperament?
 A. I am very calm
 B. I respond quickly and passion-ately
 C. I don't stay mad for long
 D. I don't get mad often, but when I do, watch out
 E. I am unpredictable

3. Choose your favorite activity
 A. Surfing
 B. Attending a sporting event
 C. Shopping
 D. Watching movies
 E. Music concert

4. You win! What prize most excites you:
 A. A shopping spree
 B. A trip to a country you've never visited
 C. An adventure experience
 D. Free tickets to your favorite sports team
 E. A car

5. What is your favorite pizza topping?
 A. Pepperoni
 B. Extra cheese
 C. Pineapple
 D. Bacon
 E. Olives

6. Which flavor are you drawn to?
 - A. Zesty
 - B. Tart
 - C. Rich
 - D. Salty
 - E. Spicy

7. Where would you like to spend a sunny afternoon?
 - A. Beach
 - B. Picnic at the park
 - C. The mall
 - D. My house relaxing
 - E. Circus

8. Pick your favorite cartoon character.
 - A. Scooby-Doo
 - B. Bugs Bunny
 - C. Sponge Bob
 - D. Snoopy
 - E. Stimpy

9. How often do you eat junk food?
 - A. Not very often
 - B. 2-3 times per week
 - C. Every day
 - D. Once a week
 - E. As often as I can

10. What color do you like most?
 - A. Blue
 - B. Red
 - C. Yellow
 - D. Black
 - E. Green

Score Guide

1. A=1, B=2, C=3, D=4, E=5 **2.** A=4, B=2, C=3, D=1, E=3 **3.** A=1, B=2, C=3, D=4, E=5

4. A=3, B=5, C=1, D=2, E=4 **5.** A=4, B=3, C=5, D=2, E=1 **6.** A=5, B=1, C=3, D=4, E=2

7. A=1, B=2, C=3, D=4, E=5 **8.** A=1, B=2, C=3, D=4, E=5 **9.** A=1, B=5, C=2, D=4, E=3

10. A=1, B=2, C=3, D=4, E=5

Your Total Score _____

Results

10-17 Salt & Vinegar

You are wild and free and are very in tune with the Earth. You prefer to be outdoors and love the ocean. More than likely you're a vegetarian or eat less meat than most. You are easy to get along with and don't like strife. You are a balance of calm, cool and collected and have a work hard/play hard mentality.

18-25 BBQ

You are a favorite and never lacking in spice. You are loud, the life of the party and love lots of attention. You are very passionate about the things in life you love. You don't get along with everyone, and doesn't bother you because the relationships you have are strong and fulfilling.

26-33 Cheddar

You enjoy the finer things in life and love to treat yourself. You can be selfish, but you're usually kind to people you meet. You are not a big fan of being outdoors and you will always pick shopping above any other activity. You don't like working for other people and you're usually running late.

34-41 Plain and tall

You're the original potato chip. You are shy and quiet, but that doesn't mean you're fla-vorless. You don't like change or chaos. You're a homebody and love to watch movies, cook and relax. You can be pretty romantic and affectionate with your mate. You don't mind outdoors but only when it's nice out.

42-50 Sour cream and onion

You are unique, playful, quirky and eccentric and stand out in a crowd. You're indepen-dent and highly opinionated. You like meeting new people and trying new things. You'd rather spend your time leisurely than working and you don't take life too seriously.

HOW BRAVE ARE YOU?

We all like to think we'd rise to the occasion, but when the chips are down and it's time to make a choice, how would you measure up?

1. Who do you look up to?
 - A. A parent or family member
 - B. Members of the armed forces
 - C. A personal mentor
 - D. Professional athletes
 - E. Firefighters or police officers

2. What category do most of your fears fall into?
 - A. Spiders, snakes, creepy crawlies in general
 - B. Violent confrontations
 - C. Loved ones getting hurt or sick
 - D. It's not what you fear, but how you respond to fear that counts
 - E. Nothing scares me!

3. Have you ever done anything you consider brave?
 - A. Just once
 - B. All the time
 - C. No, I tend to play it safe
 - D. Not that I can remember
 - E. A few times

4. What is your most frequent nightmare?
 - A. Being trapped or buried alive
 - B. Being helpless when I want to act
 - C. Running from an unknown figure
 - D. Falling from a great height
 - E. My teeth falling out

5. Which of these activities would you like to do/have you done?
 - A. Donate blood
 - B. Travel the world
 - C. Skydiving or bungee jumping
 - D. Rock or mountain climbing
 - E. None of the above

6. Pick the person you admire most for being brave.
 A. Martin Luther King, Jr.
 B. Muhammed Ali
 C. Mother Teresa
 D. Rosa Parks
 E. I can't choose just one

7. What is the bravest act listed below in your opinion?
 A. Rescuing someone in danger
 B. Protecting your country
 C. Standing up to a bully
 D. Taking a stand against an injustice
 E. Protecting and serving your community and its residents

8. What trait does someone brave possess?
 A. Integrity
 B. Courage
 C. Confidence
 D. Honesty
 E. Self-sacrifice

9. How brave would you rate yourself?
 A. Average
 B. Above average
 C. I need to learn how to be braver
 D. Depends on the situation
 E. Brave enough

10. How do you think the media reflects on people who are brave?
 A. Moderately
 B. They pick and choose unfairly
 C. I think they are fair
 D. The media seems biased
 E. They need improvement

Score Guide

1. A=3, B=5, C=1, D=4, E=2 **2.** A=3, B=4, C=1, D=5, E=2 **3.** A=1, B=2, C=3, D=4, E=5
4. A=1, B=5, C=4, D=2, E=3 **5.** A=5, B=4, C=2, D=1, E=3 **6.** A=5, B=2, C=3, D=1, E=4
7. A=2, B=5, C=3, D=4, E=1 **8.** A=4, B=2, C=3, D=1, E=5 **9.** A=1, B=2, C=3, D=4, E=5
10. A=1, B=2, C=3, D=4, E=5

Your Total Score _____

Results

10-17 Just right

You have a healthy level of bravery brewing inside you. You don't go out of your way to exercise bravery, but in the right situation you will be measured and you will surpass.

18-25 Overtly brave

You are bold and brave and pride yourself on helping others. You respect bravery but at times you can go out of your way to show off your boldness. Tone down the overzealousness and you will be just right.

26-33 Play it safe

You are a bit below average in the bravery department and could use a good dose of self-confidence. You love stories of bravery, but you need to trust yourself and your abilities more. Know how valuable you are so when the time comes you can step up.

34-41 Brave but don't know it

You may be brave, but you don't know it yet because your bravery has never been put to the test. Given the chance you would step up to the plate.

42-50 Self-sacrificing do-gooder

You are brave in service of the greater good. You don't care if you get attention or acknowledgment for your good deeds, as long as you do what needs to be done to help as many people as possible.

When you win the Oscar, which category will it be? The process of making movies pulls from many different strengths and interests. If you were to arrive on a movie set, which job would suit you most?

1. Would you rather:
 A. Choose the symphony
 B. Play the violin
 C. Compose a melody
 D. Conduct the orchestra
 E. Decorate the stage

2. Would you rather:
 A. Forget the words to your favorite song
 B. Forget an acquaintance's name
 C. Forget your wallet
 D. Forget a friend's birthday
 E. Forget your gloves

3. Would you rather be:
 A. A painter
 B. A singer
 C. A politician
 D. An author
 E. An architect

4. Would you rather be:
 A. Unkempt
 B. Dirty
 C. Late
 D. Tired
 E. Unpopular

5. Would you rather:
 A. Discover a bundle of cash
 B. Discover an old cherished photo
 C. Discover an uncharted island
 D. Discover an unknown artist
 E. Discover a new novel series

6. Would you rather:
 A. Build with Legos
 B. Build a sandcastle
 C. Build a pillow fort
 D. Build a house
 E. Build a model airplane

7. Would you rather:
 A. Make your own clothes
 B. Start your own clothing line
 C. Shop at thrift stores
 D. Run a clothing factory
 E. Represent a clothing brand

8. You're alone. Would you rather:
 A. Talk to yourself
 B. Write in a journal
 C. Dance or sing unseen and unheard
 D. Make something crafty
 E. Do whatever I want

9. You have stuff stuck in your teeth. Would you rather:
 A. Have someone tell me about it and bring me some floss
 B. Notice it before anyone sees
 C. I don't care
 D. Take care of it myself and figure out what it was
 E. Mess with it with my tongue until it comes out

10. Would you rather:
 A. Get the latest best seller in hardcover
 B. Turn the latest bestseller into a movie
 C. Find a rare first edition
 D. Reread an old favorite
 E. Get a pile of awesome used paperbacks

Score Guide

1. A=1, B=5, C=3, D=2, E=4 **2.** A=5, B=2, C=3, D=1, E=4 **3.** A=4, B=5, C=2, D=3, E=1

4. A=3, B=4, C=5, D=2, E=1 **5.** A=2, B=5, C=1, D=4, E=3 **6.** A=4, B=3, C=5, D=1, E=2

7. A=4, B=2, C=3, D=1, E=5 **8.** A=5, B=3, C=2, D=4, E=1 **9.** A=1, B=5, C=3, D=2, E=4

10. A=2, B=1, C=5, D=3, E=4

Your Total Score _____

Results

10-17 Producer

You are most concerned with the big picture. You love to influence all aspects of a project, including the finances, and be the ultimate authority on all of it from top to bottom.

18-25 Director

You like to set the tone and coordinate others to follow it. You don't want to be the big boss, because you don't want to be responsible for the budget, but you like a wide scope of vision.

26-33 Screen Writer

You're an ideas person. You come up with a story, characters and dialog, then let someone else make them happen. None of it would happen without you, but you're not big on attention.

34-41 Costume or Set Designer

You are an artist and bring the story to life in vivid color. You help the actors do their jobs by creating a rich, authentic and tactile environment.

42-50 Actor

You are the face and voice of the movie. You love the limelight, attention, and immediate reaction that acting brings, but you also need time to reflect.

ARE YOU A MAD SCIENTIST?

Do you look at weird things, find them fascinating, and wonder how they work? Test your scientific knowledge and inquisitiveness with these ten questions.

1. Is there intelligent life on other planets?
 A. Probably
 B. I don't know
 C. Absolutely, and I'm ready to be an ambassador

2. Where do you find hemoglobin?
 A. Red blood cells
 B. Blood
 C. The liver

3. Who invented the first lightning rod?
 A. Benjamin Franklin
 B. A Russian industrialist
 C. Alexander Graham Bell

4. What are humans made of?
 A. The same elements and minerals as the sea
 B. Stardust
 C. Flesh and blood

5. Is time travel really possible?
 A. It's happening now
 B. No
 C. It will be in the future

6. Where would you rather work?
 A. The International Space Station
 B. NASA
 C. Your own laboratory

7. What is it called when two hydrogen atoms combine to form helium?
 A. Water
 B. A molecule
 C. Fusion

8. How big is the universe?
 A. It can't be measured
 B. Billions of lightyears
 C. You mean "universes"

9. Who is your favorite scientist?
 A. Neil DeGrasse Tyson
 B. Isaac Newton
 C. Galileo Galilei

10. What is Pluto?
 A. A planet
 B. A moon
 C. A dwarf planet

Score Guide

1. A = 2, B = 1, C = 3 **2.** A = 3, B = 2, C = 1 **3.** A = 2, B = 3, C = 1
4. A = 2, B = 3, C = 1 **5.** A = 3, B = 1, C = 2 **6.** A = 2, B = 1, C = 3
7. A = 1, B = 2, C = 3 **8.** A = 1, B = 3, C = 3 **9.** A = 3, B = 1, C = 2
10. A = 2, B = 1, C = 3

Your Total Score _____

Results

10-17 Not much madness

Science isn't really your cup of cosmic ooze. It's cool in theory, but you don't remember much from school, and you liked other subjects better, anyway. You find nature and space interesting, but you don't delve too deeply into learning about it.

18-24 Mad scientist in training

You know a lot about science and find it interesting, but you haven't reached the level of madness quite yet. You have a variety of interests and don't get too obsessed with one in particular. That being said, you love science fiction movies and television shows and prefer it to other genres.

25-30 Most extraordinarily mad

Put on the goggles and lab coat! You're the maddest scientist there is, complete with knowledge, curiosity, and a healthy dose of eccentricity. You love to keep up with the latest news about innovations and discoveries, and your friends think you're either the coolest or the nerdiest person ever.

ARE YOU A MAD SCIENTIST?

HOW PICKY ARE YOU?

Are people always telling you that you are too picky? Are they right, or are they completely off-base? Time to find out!

1. How often do you send food back at an establishment that is not to your satisfaction?
 A. Never. If I didn't have to cook it, it's the best thing I've ever tasted.
 B. I've done it once, but insects are non-negotiable.
 C. I do it occasionally
 D. It depends on what is wrong with it
 E. I want it the way I want it. Is that too much to ask?

2. When ordering food do you often give special instructions or customize it?
 A. Nope. I'll have the #3.
 B. Only if I'm allergic to an ingredient.
 C. It depends on the type of food
 D. Yes, often
 E. Every time I order

3. When you go to the movies is there a specific row or side you need to sit on?
 A. Anywhere is fine
 B. As long as I can see
 C. I like to be in the middle
 D. I have a few spots I like
 E. I need to be in a specific location or I am unhappy

4. How many outfits do you try on before you find one you like?
 A. I don't try things on. I just get dressed.
 B. I may switch my shirt once in a while.
 C. I only try on a lot of options for special occasions
 D. Quite a few.
 E. It takes me forever to get it just right.

5. How long does it take you to get ready in the mornings?
 A. 5 minutes or less
 B. 15 – 30 minutes
 C. 45 minutes
 D. 1 hour
 E. Over an hour

6. How do you like your pizza?

 A. I like it all, it's pizza
 B. Leftover pizza is the best
 C. Anyway is fine, I just pick off a topping I don't like
 D. Hot, fresh and made to order
 E. I have a specific order my local pizza place knows by heart

7. How long does it take you to snap a selfie?

 A. First try
 B. 1-2 takes
 C. 3
 D. Quite a few
 E. About a million takes

8. Do you ever eat something you don't like?

 A. There is no food I don't like
 B. Sure, it's not a big deal
 C. If I'm hungry and it's the only option
 D. Not really
 E. I'd rather starve

9. How many times have you returned an item after you bought it?

 A. Never
 B. Only if there was a major problem or damage
 C. I just gave it to someone who liked it
 D. Sometimes
 E. All the time

10. Have you ever cried because you didn't get your way?

 A. Never. What a waste of energy.
 B. Once when I was really upset.
 C. A few times, but I was embarrassed afterward.
 D. Often. It works!
 E. All the time.

Score Guide

1. A=1, B=2, C=3, D=4, E=5 **2.** A=1, B=2, C=3, D=4, E=5 **3.** A=1, B=2, C=3, D=4, E=5

4. A=1, B=2, C=3, D=4, E=5 **5.** A=1, B=2, C=3, D=4, E=5 **6.** A=1, B=2, C=3, D=4, E=5

7. A=1, B=2, C=3, D=4, E=5 **8.** A=1, B=2, C=3, D=4, E=5 **9.** A=1, B=2, C=3, D=4, E=5

10. A=1, B=2, C=3, D=4, E=5

Your Total Score _____

Results

10-17 Totally easy-going

You are never picky. You are very easy to please and take life as it comes. It doesn't bother you if things are not perfect, and you don't expect them to be. You will try anything and have a very open mind. In fact you could stand to be a little bit pickier.

18-25 Laid back, to a point

You are pretty easy to please, but once and a while there may be something that you can't deal with. You normally are okay with situations and you usually don't make a fuss. You will speak your mind, but only when the need arises.

26-33 Mid-picky

You are normally happy go lucky, but you will be picky on occasion depending on the situation. You like things to be in order but you can adapt to certain imperfections. Most things don't bother you, but you can be picky when it comes to your food.

34-41 Particular

You don't settle for things if they aren't the way you want them. While you are not overly picky, you still are noticeably picky. You don't let small things bother you, but you will speak up and change the larger things that bug you. You are very particular with your appearance and cleanliness. You do your best and expect others to do the same.

42-50 Picky Nicky

You want what you what, and you want it the exact way you like it. You don't settle for less than perfection. You are upset with things if they are not just right. You are hard on yourself and others. You are super picky with food and clothes. You can be difficult to please at times.

HOW PICKY ARE YOU?

When you hear about foreign events in the news, do you know exactly where they're talking about, or do you just nod along, pretty sure you know which continent they're referring to? Put down your phone or computer and let's take a trip around the world and find out.

1. What snake-shaped country takes up most of the west coast of South America?
 A. Ecuador
 B. Chile
 C. Catalonia
 D. Portugal

2. Where is the Taj Mahal?
 A. Budapest
 B. Nepal
 C. India
 D. Vietnam

3. Copenhagen is the capital of what country?
 A. Denmark
 B. Sweden
 C. Romania
 D. Angola

4. Which of the following is one of the current seven wonders of the world?
 A. Great Wall of China
 B. Colossus of Rhodes
 C. Mount Rushmore
 D. The Grand Canyon

5. Which of the following is an island off the southeast coast of Africa?
 A. Tanzania
 B. The Azores
 C. Egypt
 D. Madagascar

6. Which U.S. state has the nickname "The Land of 1,000 Lakes"?
 A. Montana
 B. Minnesota
 C. Michigan
 D. New Mexico

7. Suriname borders what other countries?
 A. Brazil and Guiana
 B. Cambodia and Thailand
 C. Alberta and British Columbia
 D. Honduras and El Salvador

8. Johannesburg is the largest city in what country?
 A. Germany
 B. The Netherlands
 C. Botswana
 D. South Africa

9. The River Thames river is in what city?
 A. Liverpool
 B. London
 C. Dublin
 D. San Juan

10. What U.S. state only shares a border with one other state?
 A. Maine
 B. Florida
 C. Wisconsin
 D. Texas

Score Guide

1. A = 3, B = 4, C = 2, D = 1 **2.** A = 1, B = 3, C = 4, D = 2 **3.** A = 4, B = 3, C = 2, D = 1
4. A = 4, B = 3, C = 2, D = 1 **5.** A = 3, B = 1, C = 2, D = 4 **6.** A = 2, B = 4, C = 3, D = 1
7. A = 4, B = 2, C = 1, D = 3 **8.** A = 1, B = 2, C = 3, D = 4 **9.** A = 3, B = 4, C = 2, D = 1
10. A = 4, B = 3, C = 2, D = 1

Your Total Score _____

Results

10-15 Whip out that atlas

So, it didn't go so well for you. You often had the wrong end of the globe, let alone the wrong continent. Start with fun ways to brush up on your geography, like movies and books based on real places and cooking around the globe in your own kitchen.

16-25 Room for improvement

You made some educated guesses based on solid knowledge, but you often missed the mark. Fortunately, you've got a good start and it will be easy for you to hone your skills. Get specific with some documentaries or by reading authors and watching movies from foreign countries.

26-35 So close

You clearly have a strong grasp on world geography, because you had the right general area down in most cases. When you weren't sure, you made solid guesses, and you had the right region most of the time, if not the right continent. Deceiving names tripped you up a bit, but it won't take much to perfect your knowledge.

36-40 Right on target

Huzzah to you, world traveler. Who needs an atlas when they have you around? You are either a geography buff, or you pay close attention to world news, or both. Whatever the reason, you have a firm grasp of the globe and a great memory.

HOW WELL DO YOU KNOW
The World?

WHAT ZOO ANIMAL ARE YOU?

We are more like our animal brethren than we think we are. Your choices in the following questions will lead to the truth about your wilder side.

1. It's raining. Would you rather:
 A. Find shelter for yourself and the people with you.
 B. Oh, is it raining? Oh well.
 C. Curl up on the couch with your loved ones.
 D. Put on your boots and go out splashing.
 E. Whip out my umbrella and carry on.

2. You are set up on a blind date. Would you rather:
 A. Find a reason to cancel
 B. Look forward to it. I'm awesome.
 C. Look my best and go, but meet up with friends after to talk about it
 D. Meet them at my favorite casual restaurant
 E. Take my date for a hike with a picnic basket

3. You feel threatened. Would you rather:
 A. Attack head on with everything you've got
 B. Hide but be ready to strike fast
 C. Fly away
 D. Run but fight if you have to
 E. Yell loudly and scare them away

4. Would you rather:
 A. Sleep all day and be up at night
 B. Sleep outside under a tree
 C. Sleep cuddled with your honey
 D. Sleep for six months at a time
 E. Sleep a little then watch the sun rise

5. Would you rather:
 A. Eat one big meal a day
 B. Eat lots of small, high protein meals
 C. Eat a plant-based diet
 D. Eat steak
 E. Eat anything and everything

6. Which would you rather not do:

 A. Get up early
 B. Go to the gym
 C. Eat salad
 D. Spend time alone
 E. Stay in one place

7. You have to do a big project. Would you rather:

 A. Lead the team and make sure everyone is working toward their strengths
 B. Do everything together from start to finish
 C. Do it myself
 D. Get it over with quickly together then relax
 E. Brainstorm creative ways to get it done

8. Would you rather wear:

 A. Clothes that are attractive but comfortable
 B. Pajamas
 C. Dark colors
 D. Stylish clothes in muted colors
 E. Bold styles that highlight my best qualities

9. To ease your mind, would you rather:

 A. Meditate
 B. Go for a walk at night
 C. Make a plan
 D. Seek out advice
 E. Take a nap

10. A friend is making a speech about you. Would you rather he or she highlight:

 A. Your general awesomeness
 B. Your intelligence
 C. Your adventurous spirit
 D. Your fun, easy-going nature
 E. The times you came through for them

Score Guide

1. A=1, B=4, C=2, D=5, E=3 **2.** A=3, B=1, C=2, D=4, E=5 **3.** A=1, B=2, C=3, D=4, E=5

4. A=3, B=1, C=2, D=4, E=5 **5.** A=2, B=3, C=5, D=1, E=4 **6.** A=3, B=4, C=1, D=2, E=5

7. A=1, B=2, C=3, D=4, E=5 **8.** A=5, B=4, C=3, D=2, E=1 **9.** A=5, B=3, C=1, D=2, E=4

10. A=1, B=3, C=5, D=4, E=2

Your Total Score _____

Results

10-17 Lion

The lion is royalty of the savannah and the most popular zoo animal. You are loud and proud. Though you're a natural leader, you work best on a team and would do anything to protect your own. You hold your head high and are confident in your abilities, but you also believe in balance and equality and that everyone has their own strength.

18-25 Rattlesnake

Rattlesnakes are actually quite cuddly when you get to know them. They tend to pile up together for warmth and safety and don't like to be alone. You blend in with the crowd, but watch out. Though you prefer to hide or flee to avoid confrontation, you're deadly when you have no choice but to bite.

26-33 Great Horned Owl

You are wise and sharp. You are not afraid of the dark and you solve problems independently. Because you're introverted and introspective, others find you intimidating at first. Though you are hard to get to know, you're capable and reliable, and your intelligence helps you adapt well to all kinds of situations and settings.

34-41 Grizzly Bear

Grizzly bears just want to romp in the forest, find food, and go back home. You are easy going and don't let things bother you. You are big hearted but not a pack animal, preferring small social groups and close friends. You love a good meal and a long nap, and your favorite clothes are pajamas. It doesn't take much to keep you happy.

42-50 Elephant

Though they have tough hides, elephants are big softies. They love to hang onto their wildness and are natural explorers, and this makes them hard to train. You have a soul as large as your feet. You are well-loved and give genuine love in return. You are a wanderer, but you are also the glue that holds your group together. Sunshine and meditation energize you, but when it rains you embrace it and splash in the puddles.

WHAT ZOO ANIMAL ARE YOU?

DO YOU HAVE AN AWESOME VOCABULARY?

Spelling a word right doesn't mean anything if you've got the wrong word. With so many words that sound similar—or exactly the same—it takes a vocabulary master to get them all correct.

1. Complete this sentence: "This should _____ your interest."
 A. Peek
 B. Pique
 C. Peak
 D. Prick

2. Which of the following words means "agree".
 A. Assent
 B. Ascent
 C. Absent
 D. Insist

3. Which of the following words relates to the weather?
 A. Climactic
 B. Clematis
 C. Climatic
 D. Complacent

4. Which of the following is a doctor of feet?
 A. Pediatrician
 B. Podiatrist
 C. Paleontologist
 D. Psychiatrist

5. Which of the following is a city?
 A. Metronome
 B. Metronymic
 C. Metritis
 D. Metropolis

6. Finish the sentence: "I was so scared my knees started to _____."
 A. Quake
 B. Quail
 C. Quaint
 D. Quale

7. A "currant" is...
 A. A flow of electricity
 B. A fruit
 C. A river
 D. Something happening now or recently

8. Finish the sentence: "Don't _____ your lunch money."
 A. Loose
 B. Lone
 C. Lose
 D. Loot

9. A breeze of air is called a:
 A. Draught
 B. Draft
 C. Dram
 D. Diatribe

10. The first version of a piece of writing is a:
 A. Draught
 B. Draft
 C. Dram
 D. Diatribe

11. The yellow center of an egg is called a:
 A. Yoke
 B. Yokel
 C. York
 D. Yolk

12. Which of the following words applies to priests and minsters?
 A. Orchestrate
 B. Ordinary
 C. Ordained
 D. Originate

Score Guide

1. A=0, B=5, C=0, D=0	**2.** A=5, B=0, C=0, D=0	**3.** A=0, B=0, C=5, D=0
4. A=0, B=5, C=0, D=0	**5.** A=0, B=0, C=0, D=5	**6.** A=5, B=0, C=0, D=0
7. A=0, B=5, C=0, D=0	**8.** A=0, B=0, C=5, D=0	**9.** A=5, B=0, C=0, D=0
10. A=0, B=5, C=0, D=0	**11.** A=0, B=0, C=0, D=5	**12.** A=0, B=0, C=5, D=0

Your Total Score _____

Results

0-15 **It sounded right**

You prefer movies and TV, and when you dive into a book it's likely an audiobook. You are a good speaker, but you don't always realize it when you say the wrong word. But luckily, the people listening to you don't pick up on it, either, because it sounded right to them, too.

20-30 **Not too shabby**

You may not get them exactly right, but you do try to use more complicated and uncommon words in your everyday speaking and writing. Spell check doesn't always catch you because you've used the correct spelling of the wrong word. You read for pleasure on a trip or on a rainy weekend, but nothing too long or intense.

35-45 **Almost perfect**

You have a pretty decent vocabulary. You read 5-10 books a year, and you've read a lot of the classics. You tend to stick to a certain genre and read a lot by the same authors unless a friend recommends something. To get to the next level, try reading one or two books a year that are outside your comfort zone.

50-60 **You've got this, and you know it**

Your excellent vocab skills stem naturally from your bookwormish ways. You start a new book right after you finish one, and you read several times a week, if not every day. You may sometimes be reading more than one book at a time. You like to challenge yourself with long, multi-genre reads.

ARE YOU A TRUE SPORTS FAN?

It's time to test your knowledge of the world of professional athletes. Warm up, stretch, and go!

1. How many holes are on a golf course?
 A. 19
 B. 18
 C. 16
 D. 20

2. Who is the only athlete to play in a Super Bowl AND a World Series?
 A. Deion Sanders
 B. Alex Rodriguez
 C. Emmit Smith
 D. Tom Brady

3. How many soccer players should be on the field at the same time?
 A. 20
 B. 11
 C. 24
 D. 22

4. The Heisman Trophy is presented in what sport?
 A. Football
 B. Hockey
 C. Rugby
 D. Basketball

5. In what sport can one be a "heavyweight"?
 A. Football
 B. Tennis
 C. Boxing
 D. Soccer

6. What country has played in every World Cup?
 A. England
 B. Brazil
 C. Australia
 D. U.S.A.

7. What tennis player holds the most women's singles titles?
 A. Serena Williams
 B. Martina Navratilova
 C. Venus Williams
 D. Billie Jean King

8. What sport does the term "curveball" come from?
 A. Baseball
 B. Golf
 C. Basketball
 D. Tennis

9. Who said, "I've failed over and over and over again in my life and that is why I succeed."
 A. Babe Ruth
 B. Michael Jordan
 C. Peyton Manning
 D. Tiger Woods

10. Which of the following sports does not have fouls?
 A. Tennis
 B. Hockey
 C. Rugby
 D. Baseball

Score Guide

1. A=0, B=5, C=0, D=0
2. A=5, B=0, C=0, D=0
3. A=0, B=0, C=0, D=5
4. A=5, B=0, C=0, D=0
5. A=0, B=0, C=5, D=0
6. A=0, B=5, C=0, D=0
7. A=0, B=5, C=0, D=0
8. A=5, B=0, C=0, D=0
9. A=0, B=5, C=0, D=0
10. A=5, B=0, C=0, D=0

Your Total Score _____

Results

0-20 Warm up the bus
You may know a thing or two, but you're not a true sports fan.

25-40 Nice shot
You came close, but you didn't quite make it over the line.

45-50 Touchdown! Home run! Slam dunk! In other words...goooooal!
You don't need us to tell you how well you did, champ.

How much of a movie buff are you? While you may be able to quote your favorites and make a clever reference, the full names of characters are sometimes the hardest parts to remember. Challenge your film knowledge and choose the modern classic that brought these characters into our homes.

1. Sarah Connor
 - A. Terminator
 - B. Far and Away
 - C. Titanic
 - D. Gone with the Wind

2. Harry Burns
 - A. Dirty Harry
 - B. When Harry Met Sally
 - C. Harry and the Hendersons
 - D. Grease

3. Tyler Durden
 - A. Harry Potter and the Sorcerer's Stone
 - B. Ghostbusters
 - C. Fight Club
 - D. Indiana Jones

4. Ellen Ripley
 - A. The Greatest Showman
 - B. Alien
 - C. The Talented Mr. Ripley
 - D. Citizen Kane

5. Vito Corleone
 - A. Goodfellas
 - B. The Silence of the Lambs
 - C. Vertigo
 - D. The Godfather

6. Dorothy Gale
 - A. The Wizard of Oz
 - B. The Philadelphia Story
 - C. Singin' in the Rain
 - D. Casablanca

7. Patrick Bateman
 A. American Beauty
 B. American Psycho
 C. American Pie
 D. American History X

8. Miranda Priestly
 A. Mean Girls
 B. Clueless
 C. The Devil Wears Prada
 D. Cinderella

9. Celie Johnson
 A. The Color Purple
 B. Glory
 C. 12 Years a Slave
 D. Sunset Boulevard

10. Martin Brody
 A. Grumpy Old Men
 B. Rear Window
 C. The Big Sleep
 D. Jaws

11. Sam Spade
 A. North by Northwest
 B. Charade
 C. The Maltese Falcon
 D. The Big Lebowski

12. Axel Foley
 A. Trading Places
 B. Beverly Hills Cop
 C. Coming to America
 D. The Nutty Professor

Score Guide

1. A=5, B=0, C=0, D=0 2. A=0, B=5, C=0, D=0 3. A=0, B=0, C=5, D=0
4. A=0, B=5, C=0, D=0 5. A=0, B=0, C=0, D=5 6. A=5, B=0, C=0, D=0
7. A=0, B=5, C=0, D=0 8. A=0, B=0, C=5, D=0 9. A=5, B=0, C=0, D=0
10. A=0, B=0, C=0, D=5 11. A=0, B=0, C=5, D=0 12. A=0, B=5, C=0, D=0

Your Total Score _____

Results

0-15 Time for a marathon!

Pop some popcorn and put on the stretchy pants: it's time to watch some movies. You enjoy movies, but you don't tend to rewatch your favorites much or catch them when they're on TV. You prefer new releases and like to let the plot take you away without having to analyze.

20-40 Try out some new titles

You love to watch your favorites but you don't usually branch out into genres outside your comfort zone. Try asking everyone you talk to what his or her favorite movie of all time is, then add it to your Netflix list and enjoy.

45-60 Film encyclopedia

You enjoy watching old favorites as much as you like watching something new in the theater. Most of your favorite quotes of all time are from movies. You have a large DVD collection and people come to you for recommendations and opinions.

CAN YOU NAME A MOVIE BASED ON ITS MAIN CHARACTER?

Most countries only have to remember one capital, but here in the good ol' U.S.A., we have just a few more to keep track of. How well do you know your own country?

1. Which of the following is a state capital?
 A. Portland
 B. Honolulu
 C. New Orleans
 D. Kansas City

2. What is the capital of New York?
 A. New York City
 B. Buffalo
 C. Albany
 D. Rochester

3. Montgomery is the capital of what state?
 A. Alabama
 B. South Carolina
 C. Florida
 D. Wyoming

4. What is the capital of California?
 A. Sacramento
 B. San Francisco
 C. Los Angeles
 D. San Diego

5. Which of the following is NOT a state capital?
 A. Phoenix
 B. Little Rock
 C. Tallahassee
 D. Cambridge

6. What is the capital of Texas?
 A. Dallas
 B. Austin
 C. Houston
 D. El Paso

7. Juneau is the largest state capital in the country—true or false?
 A. True
 B. False

8. Helena is the capital of what state?
 A. Louisiana
 B. Montana
 C. Alaska
 D. Iowa

9. What is the capital of Wisconsin?
 A. Madison
 B. Green Bay
 C. St. Paul
 D. Harrisburg

10. What was the first national capital of the United States?
 A. Richmond
 B. New York City
 C. Providence
 D. Washington, DC

11. What is the capital of New Mexico?
 A. Albuquerque
 B. Tucson
 C. Roswell
 D. Santa Fe

12. Half of the states in the country have changed their capitals more than once—true or false?
 A. True
 B. False

Score Guide

1. A=0, B=5, C=0, D=0 **2.** A=0, B=0, C=5, D=0 **3.** A=5, B=0, C=0, D=0

4. A=5, B=0, C=0, D=0 **5.** A=0, B=0, C=0, D=5 **6.** A=0, B=5, C=0, D=0

7. A=5, B=0 **8.** A=0, B=5, C=0, D=0 **9.** A=5, B=0, C=0, D=0

10. A=0, B=5, C=0, D=0 **11.** A=0, B=0, C=0, D=5 **12.** A=5, B=0

Your Total Score _____

Results

0-20 **More like lower case**

The largest or most popular city in a state isn't always its capital, just ask Maine!

25-45 **Middle ain't bad**

Only a small percentage of Americans can name all of the state capitals, so you actually went above and beyond.

50-60 **Huzzah to you!**

Either you have an awesome memory, or you know one of the many state capitals songs by heart. (Yes, there are songs.)

Have you ever noticed how similar the names of game shows, casual dining establishments, and Hollywood flicks can be? Can you tell the difference?

1. Is "Carrabbas" a restaurant, game show, or movie title?
 A. Movie title
 B. Restaurant chain
 C. Game show

2. Is "Phffft" a restaurant, game show, or movie title?
 A. Movie title
 B. Restaurant chain
 C. Game show

3. Which of the following is a game show?
 A. Goodfellas
 B. Bennigans
 C. The Gong Show

4. Which of the following claims the "world's greatest hamburgers"?
 A. Fuddruckers
 B. Double Dare
 C. Sideways

5. What current TV show asks trivia questions in a car?
 A. Thunder Road
 B. Cash Cab
 C. Mel's Drive-In

6. Which of the following is a movie starring Tom Cruise?
 A. Wipeout
 B. Big Boy
 C. Magnolia

7. "Bob Evans" is a...
 A. Restaurant chain that specializes in country-style cooking
 B. Quiz show from the 80s hosted by TV personality, Bob Evans
 C. Film about an Olympic figure skater

8. "GoldenEye" is a...
 A. Chain of steak houses
 B. James Bond movie
 C. Celebrity game show based on poker

9. "Tic-Tac-Dough" is a...
 A. Chain of bakeries famous for its butter rolls
 B. Trivia show that aired for almost 30 years
 C. A spoof comedy starring Melissa McCarthy

10. Which of the following is an Italian restaurant chain?
 A. L'Eclisse
 B. Family Feud
 C. Buca di Beppo

Answer Key

1. B – There are hundreds of Carrabbas Italian Grill locations throughout the U.S.

2. A – *Phffft* was released in 1954 and starred Jack Lemmon.

3. C – The Gong Show aired for 13 years in the 70s and 80s.

4. A – Fuddruckers burgers are grilled to order.

5. B – Cash Cab airs on the Discovery Channel since 2005.

6. C – *Magnolia* also starred Julianna Moore.

7. A – The Bob Evans kids menu features pancakes shaped like pigs.

8. B – GoldenEye starred Pierce Brosnan as Bond.

9. B – On "Tic-Tac-Dough" a correct answer led to putting an X or O on the board.

10. C – Buca di Beppo means "Joe's Basement".

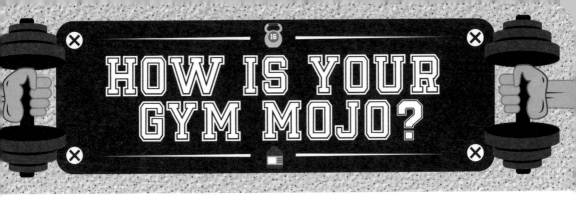

HOW IS YOUR GYM MOJO?

Most people have a love/hate relationship with the gym, if they have a relationship with it at all. Do you work out enough, too much or are you on point with your gym flow?

1. How many times a week do you work out or go to the gym?
 A. Every week day
 B. Once
 C. 2 – 3 times
 D. Never
 E. Every day

2. What is your favorite way to work out?
 A. Lifting the remote or a book
 B. Cardio and weight training
 C. Gym equipment or playing sports
 D. Walking
 E. I like it all and try all the new fads

3. Pick your favorite piece of equipment at the gym?
 A. Elliptical
 B. Treadmill
 C. Sauna
 D. Weight machines
 E. All the above

4. What type of classes do you take at the gym?
 A. High intensity interval training
 B. Yoga
 C. Aerobics
 D. Kickboxing
 E. Tai Chi

5. What is your idea of the perfect snack?
 A. Candy
 B. Chips
 C. Fruit
 D. Protein shake or bar
 E. A hard-boiled egg

6. How much energy do you have daily?
 A. I've been feeling sluggish
 B. Tons
 C. I'm fine
 D. Plenty
 E. I'm ok if I've had my coffee

7. How do you feel about working out?
 A. It's torture
 B. I'm always glad after I've done it
 C. I don't feel right without it
 D. It makes me feel good
 E. I enjoy it

8. Why do you work out?
 A. I don't
 B. I try and get into shape
 C. To stay fit
 D. Because it's good for you
 E. It makes me feel great

9. What is your favorite sport to play?
 A. Swimming
 B. Golf
 C. Tennis
 D. Basketball
 E. Football

10. What do you dislike most about gyms?
 A. The cost
 B. They're not open 24 hours
 C. The locker rooms
 D. I have to pick just one thing?
 E. The crowds

Score Guide

1. A=4, B=2, C=3, D=1, E=5 **2.** A=1, B=4, C=3, D=2, E=5 **3.** A=3, B=2, C=1, D=4, E=5
4. A=5, B=2, C=3, D=4, E=1 **5.** A=1, B=2, C=3, D=4, E=5 **6.** A=1, B=5, C=3, D=4, E=2
7. A=1, B=2, C=5, D=4, E=3 **8.** A=1, B=2, C=3, D=4, E=5 **9.** A=2, B=1, C=4, D=3, E=5
10. A=4, B=5, C=3, D=1, E=2

Your Total Score _____

Results

10-17 Do mental workouts count?

The gym is not the place for you. You're more of a couch potato and prefer mental stimulation rather than the physical. Start by incorporating more movement into your day and find ways to exercise that you enjoy.

18-25 Motivate to move

You work out occasionally when you have time or feel like it. You don't hate the gym, but it's not your favorite place, either. Try to get in one more workout a week and you'll be on your way to improvement.

26-33 Friend of fitness

You are well balanced with your work outs and life. You go to the gym, but you prefer other forms of exercise. You're more like an adventurer than a hardcore gym addict, but you get plenty of physical activity.

34-41 Fitness icon

You are active at the gym and fit in general. You love the way working out makes you feel and staying in shape is important to you. You inspire others to work out.

42-50 Gym = Life

Your life centers around working out. You love the gym and all types of physical activities. Your physical image is important to you, and you want to be in the best shape possible. You could take a break but we know you won't.

Do you spend too much time on the couch? Is your middle name "Spud"?
Don't wait until you turn into a potato chip—take this quiz to find out!

1. How many hours a day do you watch TV?
 A. I don't like TV
 B. 1 – 2
 C. 3
 D. 4 - 5
 E. Almost all day

2. How many times a week do you exercise or go for a walk?
 A. Seldom
 B. 3 – 5 times
 C. 2 is a victory
 D. Almost everyday
 E. Never

3. What's your favorite snack food?
 A. Popcorn
 B. Chips or candy
 C. Protein bar
 D. Trail mix
 E. Fruit

4. If you miss your favorite show, how do you feel?
 A. I just try to watch it another time
 B. I don't miss shows because I record them
 C. I don't have favorite shows
 D. I'm upset and throw the remote
 E. It's no big deal

5. Which of these activities would you rather be doing?
 A. An outdoor adventure
 B. Watching TV
 C. Shopping
 D. Napping
 E. Hanging out with friends

6. How do you prefer to watch a movie?
 A. Rent, on cable or pay per view
 B. When it comes on TV
 C. At the movie theatre
 D. I watch some of it, but I get bored and finish it another time
 E. From the comfort of my home

7. What's your ideal way to spend an afternoon?
 A. At the beach
 B. At the mall
 C. Playing sports
 D. Listening to music and surfing social media
 E. Chilling at home

8. What's the first thing you do when you wake up?
 A. Turn on the TV
 B. Brush my teeth and shower
 C. Call a friend or text
 D. Eat breakfast
 E. Get ready for my day

9. When was the last time you turned the TV on?
 A. Can't remember. I lost the remote a long time ago
 B. Today
 C. Last week
 D. I turned it on to watch the news last night
 E. Yesterday. I follow a few shows closely

10. What is on your couch?
 A. Pillows and blankets
 B. It's a bit cluttered but there's room to sit if you shove it over
 C. It's where I keep my running and biking gear
 D. It's my home office
 E. Laundry and coats

Score Guide

1. A=1, B=2, C=3, D=4, E=5 **2.** A=4, B=2, C=3, D=1, E=5 **3.** A=4, B=5, C=1, D=3, E=2
4. A=3, B=5, C=1, D=4, E=2 **5.** A=1, B=5, C=3, D=4, E=2 **6.** A=4, B=2, C=3, D=1, E=5
7. A=2, B=3, C=1, D=4, E=5 **8.** A=5, B=2, C=3, D=4, E=1 **9.** A=1, B=5, C=2, D=3, E=4
10. A=5, B=3, C=1, D=4, E=2

Your Total Score _____

Results

10-17 **You're no potato**

You love to go on adventures and live life to the fullest. You're committed to all your activities and hate to lay around doing nothing. You are the opposite of couch potato. You're happiest when you're active.

18-25 **You're more of an oven-baked potato chip**

You enjoy hanging out and a more social scene. While you enjoy the occasional time to relax, it is not your main objective. You are popular and sociable and love surrounding yourself with all that is happening, friends and activities.

26-33 **Bit of a French Fry**

You have just a pinch of couch potato in you. While you like going out and being social you do need your down time, too. You like the best of both worlds: quiet re-laxation, mixed with social activities. You are well balanced, giving yourself enough of each but without going overboard in any direction.

34-41 **Crispy hash brown**

You are somewhat a couch potato. You don't get out much, but when you do you like to be social. You prefer the comfort of your home, but your close friends are around often.

42-50 **Loaded creamy mashed potato**

You're a major couch potato. You could use some more time outdoors or on the social scene. You love your TV, games and just lounging around your home. You don't like being around crowds and you have a small group of friends to whom you're dedicated.

Can you win the baseball match game?

Match each player or coach with his team and answer a little light trivia to win the baseball match game!

1. What team did Joe Torre coach through six American League pennants and four World Series?
 A. Indians
 B. Yankees
 C. Red Sox
 D. Mets

2. Which famous New York Yankee said, "Today, I consider myself the luckiest man on the face of the earth" when he left the game?
 A. Joe DiMaggio
 B. Yankees
 C. Red Sox
 D. Mets

3. On which team did Willie Mays play (and win the 1954 World Series)?
 A. New York Giants
 B. San Francisco Giants
 C. Baltimore Orioles
 D. Detroit Tigers

4. For which team did Sammy Sosa play right field?
 A. Chicago Cubs
 B. Los Angeles Dodgers
 C. NY Yankees
 D. Washington Nationals

5. Starting pitcher and four-time Cy Young Award winner, Greg Maddux, played for which team?
 A. Kansas City Royals
 B. Colorado Rockies
 C. Boston Red Sox
 D. Atlanta Braves

6. Which Baltimore Oriole said, "You could be a kid for as long as you want when you play baseball."
 A. Cal Ripken, Jr. C. Brooks Robinson
 B. Frank Robinson D. Jim Palmer

7. Nicknamed "The Splendid Splinter", who played for the Boston Red Sox for 19 years, only interrupting his career to serve in WWII and the Korean War?
 A. Rico Petrocelli C. Ted Williams
 B. Jonathan Papelbon D. Dom DiMaggio

8. William Joseph Klem, who said, "Baseball is more than a game to me, it's a religion" played what role?
 A. Player C. Coach
 B. Umpire D. Manager

9. What Detroit Tiger holds the record for the highest batting average?
 A. Babe Ruth C. Hank Aaron
 B. Jackie Robinson D. Ty Cobb

10. Which of the following teams still exists today?
 A. Brooklyn Dodgers C. Baltimore Orioles
 B. Montreal Expos D. Boston Braves

Score Guide

1. A=0, B=5, C=0, D=0 **2.** A=0, B=0, C=5, D=0 **3.** A=5, B=0, C=0, D=0
4. A=5, B=0, C=0, D=0 **5.** A=0, B=0, C=0, D=5 **6.** A=5, B=0, C=0, D=0
7. A=0, B=0, C=5, D=0 **8.** A=0, B=5, C=0, D=0 **9.** A=0, B=0, C=0, D=5
10. A=0, B=0, C=5, D=0

Your Total Score _____

Results

0-15 Not a fan of the American Pastime?

You may enjoy a hotdog and a beer on a summer's day and go to a game with friends, but you don't really follow baseball. You recognize the famous players, but that's about it.

20-35 Appreciate the game

You have a favorite team to which you are loyal and you follow the World Series. You don't pay much attention to other teams or care much about trades and contracts if it doesn't affect your team.

40-50 Foam finger and face paint fan

You have a favorite team and attend games when you can. When you can't, you watch the game on TV. You're a true fan of your team and of the game in general.

Can you win the baseball match game?

Are you the chief of the grammar police, or a rookie?

1. A semicolon separates two:
 A. Independent clauses
 B. Quotations
 C. Phrases
 D. Introductory clauses

2. Which sentence is correct?
 A. How's you're job hunt coming along?
 B. How is your job hunt coming along.
 C. Hows your job hunt coming along?
 D. How's your job hunt coming along?

3. Which sentence is correct?
 A. That movie effected me greatly.
 B. That movie effected me grately.
 C. That movie affected me greatly.
 D. That movie affected me great.

4. Which sentence is correct?
 A. Will you join Susan and me for dinner?
 B. Will you join Susan and I for dinner?
 C. Will you join Susan and myself for dinner
 D. Will you join me and Susan for dinner?

5. Which word is the subject of this sentence: "She is a great thinker when it comes to chemistry"?
 A. Thinker
 B. She
 C. Chemistry
 D. Is

6. Which sentence is a metaphor?
 A. He was a lone wolf.
 B. He was upset.
 C. He's as happy as a clam.
 D. He doesn't like soup.

7. Which of the following puts the comma in the right place?
 A. I don't care for mushrooms, but my mother really loves them.
 B. I don't care for mushrooms but my mother, really loves them.
 C. I don't care for mushrooms but, my mother really loves them.
 D. A and B

8. Which sentence is correct?
 A. Its not their fault.
 B. It's not there fault.
 C. It's not their fault.
 D. None of the above.

9. Which sentence is correct?
 A. At the grocery store, we need bread, milk, eggs, and cheese.
 B. At the grocery store, we need; bread, milk, eggs and cheese.
 C. At the grocery store, we need bread, milk, eggs and cheese.
 D. A and C

10. Which of the following uses "whom" correctly?
 A. Whom did you see at the mall?
 B. Whom cares?
 C. Whom is chasing that dog?
 D. Whom ate the last cookie?

Score Guide

1. A=5, B=0, C=0, D=0 **2.** A=0, B=0, C=0, D=5 **3.** A=0, B=0, C=5, D=0

4. A=5, B=0, C=0, D=0 **5.** A=0, B=5, C=0, D=0 **6.** A=5, B=0, C=0, D=0

7. A=0, B=0, C=0, D=5 **8.** A=0, B=0, C=5, D=0 **9.** A=0, B=0, C=0, D=5

10. A=5, B=0, C=0, D=0

Your Total Score _____

Results

0-15 Not your area of expertise

Okay, so you didn't get many right. Nerd-dom just isn't your thing. To improve, add some more reading time into your daily life.

20-30 Solid work, grasshopper

You have a strong foundation, but the more complicated stuff stumped you. You may not have a career as an author or editor, but you express yourself in writing well.

35-40 Bow down to the word wizard

Your friends and coworkers come to you for proofreading often, and with good reason. You know the basics and beyond!

ARE YOU A TOTAL CRANKY PANTS?

Do you ever feel agitated or upset for no reason? Are you in a bad mood all the time, or are you a bucket full of sunshine? How cranky are you, really?

1. Are you a morning person?
 A. Up and at 'em! Early bird gets the worm.
 B. Yes, I love being up in the quiet time before the world's awake.
 C. As long as "morning" isn't too early...
 D. I'm human after a cup of coffee or twelve.
 E. Why is the world so darn bright?

2. How do you feel about social media?
 A. It's a cool way to keep up with friends and family I don't get to see often.
 B. It's a waste of time.
 C. I like sharing my opinions and finding like-minded people online.
 D. I can't imagine my life without it.
 E. I check in on it a couple of times a week so I don't lose touch, but life's busy!

3. What do you do when your doorbell rings?
 A. Pretend I'm not home unless I'm expecting someone.
 B. Look through the peep hole or window to see if it's worth answering.
 C. Answer it, of course.
 D. Yell "Hang on a minute!" and grumble my way over.
 E. Open the door with a smile and invite whomever it is inside.

4. Do you keep up with current events?
 A. I watch the news and listen to the radio now and then.
 B. Why bother? It's always the same bad news, anyways
 C. I skim the headlines in the morning and evening.
 D. Yes, and I write strongly-worded letters to the editor, too.
 E. I follow the news and discuss it with friends and colleagues.

5. An invitation to a family reunion arrives in the mail. Do you:
 A. Happy dance!
 B. RSVP in a week or two.
 C. Eyeroll. Attend with dread.
 D. Look forward to seeing everyone again.
 E. Pretend the invite got lost in the mail.

6. You overhear a stranger saying something with which you strongly disagree. Do you:
 A. Tell them to have a nice day.
 B. Live and let live.
 C. Silently judge them and soon forget all about it.
 D. Jump in and challenge their remarks.
 E. Ignore them and complain about it to the next friend you talk to.

7. How often would you travel if money weren't an issue?
 A. I'd try to go away as often as I can.
 B. All the time—from day trips, to weekends away, to international vacations.
 C. Money aside? Cruise time!
 D. I guess I'd go on a trip once a year or so.
 E. Still a waste of money in my book.

8. You find out an acquaintance doesn't like you. How do you respond?
 A. I don't care.
 B. Oh, like they're so perfect??
 C. It bothers me, but what can you do?
 D. I engage with them more and try to find out what's wrong.
 E. Invite them to every party I host, making extra time to get to make them feel special.

9. What do you want to do when you retire?
 A. Retire? Fat chance in this economy.
 B. Spend more time with my family.
 C. Travel and enjoy every day
 D. Volunteer and maybe work part time.
 E. All I know is I can't wait to leave my job.

10. Someone bumps into you. Do you:
 A. Stop them and demand an apology.
 B. Say something rude.
 C. Apologize.
 D. Tell them it's okay and make sure they're alright.
 E. Frown and move on.

Score Guide
1. A=1, B=2, C=3, D=4, E=5 **2.** A=2, B=5, C=4, D=1, E=3 **3.** A=5, B=4, C=2, D=3, E=1
4. A=3, B=5, C=2, D=4, E=1 **5.** A=1, B=3, C=4, D=2, E=5 **6.** A=1, B=2, C=3, D=4, E=5
7. A=3, B=1, C=2, D=4, E=5 **8.** A=5, B=4, C=3, D=2, E=1 **9.** A=4, B=2, C=1, D=3, E=5
10. A=4, B=5, C=2, D=1, E=3

Your Total Score _____

Results

10-17 Sunny and funny 24/7

You don't have a cranky bone in your body. In fact, if you looked inside your bones, you'd probably find glitter.

18-25 Joy patrol

You have a positive outlook, you like other people, and they like you. You're not sickeningly sweet, but you live on the sunny side of the street.

26-33 Well-adjusted

You're not all unicorns and rainbows, but you also don't let things get to you. You have a healthy outlook and lots of friends.

34-41 Don't test me

You tend to see the glass as half empty, and you don't keep it to yourself. You confront the many, many things that upset you and voice your skepticism. A few true friends get you and are willing to put up with your bluster.

42-50 Leave me alone

You're the kind of cranky that doesn't care or make apologies. You don't suffer fools, which is pretty much everyone, but you don't waste energy setting them straight, either.

DO PEOPLE THINK YOU'RE FUNNY?

When your friends laugh, are they laughing with you or at you? Do you inspire genuine humor, or sympathetic smiles? Let's find out!

1. Who laughs the most at your jokes?
 A. Me
 B. A couple of close friends
 C. Lots of people

2. Choose a movie:
 A. The Three Stooges
 B. Anchorman
 C. The Royal Tenenbaums

3. Choose a comedian:
 A. Jerry Seinfeld
 B. Robin Williams
 C. Jerry Lewis

4. Which word is funniest?
 A. Bumbershoot
 B. Malarkey
 C. Fart

5. What kind of humor do you prefer?
 A. Telling jokes and making puns
 B. Pointing out humorous things
 C. Making fun or yourself

6. What is funniest?
 A. A knock knock joke or limerick
 B. A prat fall
 C. A spontaneous clever remark

7. Choose a funny TV show:
 A. Friends
 B. The Honeymooners
 C. Arrested Development

8. Who would you rather be friends with?
 A. Chandler Bing
 B. Liz Lemon
 C. Michael Scott

9. When someone falls down, do you:
 A. Laugh
 B. Make sure they're ok, then laugh
 C. Fall down while helping them get up

10. When someone says something you disagree with, do you:
 A. Say something sarcastic
 B. Make fun of them to their face
 C. Use them in a joke to others later

Score Guide

1. A = 1, B = 2, C = 3 **2.** A = 1, B = 3, C = 2 **3.** A = 2, B = 3, C = 1
4. A = 2, B = 3, C = 1 **5.** A = 1, B = 2, C = 3 **6.** A = 1, B = 3, C = 2
7. A = 3, B = 1, C = 2 **8.** A = 3, B = 2, C = 1 **9.** A = 1, B = 2, C = 3
10. A = 2, B = 1, C = 3

Your Total Score _____

Results

10-15 Captain Eyeroll

You tickle yourself pink, but those around you don't quite get the joke. You may take too many opportunities to be funny, or you may just be trying too hard. Relax and learn to spot the right moment.

16-22 Punmaster General

You have a specific kind of humor, and friends who really appreciate you think you're funny. Your humor tends to be clever and dry, so not everyone gets it or can tell you're making a joke.

23-33 Barrel of Laughs

Both friends and strangers find you amusing. You don't take yourself too seriously, and you don't try to force humor, so your combination of good timing and light-heartedness make you "the funny one" in the group.

HOW ADDICTED TO SOCIAL MEDIA ARE YOU, REALLY?

Do you know what's trending? How much do you know your friend's life, or are you too busy taking selfies? Are you spending too much time online?

1. On how many social media apps do you have an account?
 A. Just one.
 B. 2-3, but I don't really update them all.
 C. 4-5, and I use some more than others.
 D. 6+ and I use a special app to post to them all at the same time.
 E. All of them. My notifications are constant.

2. How many times a day do you check your social media?
 A. Once, sometimes none.
 B. Once or twice.
 C. About three times a day.
 D. Every hour.
 E. Too many to count, it's all day.

3. How often do you take a photo of your food and share it?
 A. Never.
 B. On holidays or a special occasion.
 C. Once in a while when I eat out some-place fancy and the food is really pretty.
 D. Several times a week.
 E. Daily. Every latte is documented.

4. How frequently do you like your friends' posts?
 A. When I have time to check their feeds.
 B. When they post something that applies to me.
 C. I do it at least once a day.
 D. I'm too busy posting my own stuff.
 E. I'm a super friend I like everything they post.

5. Which of these activities would you rather be doing?
 A. Something adventurous or outdoors.
 B. Catching up on sleep, work or my favorite TV show.
 C. At a party taking pictures with my friends.
 D. It doesn't matter as long as I can hashtag it.
 E. I'm happy taking quizzes like these and spending the day on social media.

123

6. What is the first thing you do when you wake up?

 A. Brush my teeth and get ready for the day.
 B. Immediately get breakfast.
 C. Take a shower then check social media.
 D. Wake up, stretch then check social media.
 E. I reach for my phone before my eyes are even open.

7. What's the longest you think you could go without checking your social media?

 A. I could live without it.
 B. Probably a few weeks.
 C. A week but that's pushing it.
 D. A day and then I will be having a fit.
 E. Are you joking? I won't last 5 minutes.

8. Does it matter to you if people like your posts or photos?

 A. I don't post much. I mostly just follow along.
 B. Not really, I post things for myself.
 C. It matters to me somewhat.
 D. Yes it matters.
 E. It means everything to me.

9. Has being on social media ever made you late for something or gotten you into trouble?

 A. I'd never let that happen.
 B. I've had a few close calls but nothing major.
 C. 1 - 2 times.
 D. Several times.
 E. It happens all the time.

10. Have you ever lost sleep playing on social media?

 A. No way.
 B. I've stayed up late but didn't lose sleep.
 C. Once or twice I've been on really late.
 D. It happens at least once a week.
 E. It happens all the time.

Score Guide

1. A=1, B=2, C=3, D=4, E=5 **2.** A=1, B=2, C=3, D=4, E=5 **3.** A=1, B=2, C=3, D=4, E=5

4. A=1, B=2, C=3, D=4, E=5 **5.** A=1, B=2, C=3, D=4, E=5 **6.** A=1, B=2, C=3, D=4, E=5

7. A=1, B=2, C=3, D=4, E=5 **8.** A=1, B=2, C=3, D=4, E=5 **9.** A=1, B=2, C=3, D=4, E=5

10. A=1, B=2, C=3, D=4, E=5

Your Total Score _____

Results

10-17 Not addicted at all

You like social media but it's take it or leave it. Your drive and zest for life are more important to you. You get on occasionally to check in with family and friends, but you'd much rather be doing something else. Your priorities are in check and your focus will take you far.

18-25 Savvy but sensible

You have a healthy interest in social media but it doesn't control your life. You enjoy it, but it's not your first priority. You are happy staying in touch with people but don't like too much invasion into your space. That balance will serve you well throughout life.

26-33 Enthusiastic participant

You are the typical social media user. You engage and you love it. You use the apps how they are designed and have a good number of followers but still manage to enjoy your three-dimensional life. You enjoy documenting all your adventures through social media and enjoy staying in touch.

34-41 Growing addiction

You love social media and it's very hard for you to stay off of it. You are very active: posting, sharing and messaging. You have tons of followers and you spend a lot of your free time on social media. Sometimes your attention to social media hurts your work and relationships.

42-50 Super addicted

Your life revolves around social media. You find it impossible to stay off of it and you are extremely active. Something doesn't feel like it's actually happened unless you've posted about it. You want to know everything the moment it happens from breaking news to what's trending.

HOW WELL DO YOU KNOW THE HUMAN BODY?

We all have one, and the parts are the same for all of us. Do you know where everything is in the human body?

1. What makes up the integumentary system?
 A. Skin
 B. Hormones
 C. Ligaments
 D. Eyes

2. Where are the carpal bones located?
 A. The feet
 B. The hands
 C. The knees
 D. The skull

3. Which bones are located in the lower leg?
 A. The radius and ulna
 B. The malleus, incus and stapes
 C. The tibia and fibula
 D. The occipital and parietal

4. How many chambers are in the human heart?
 A. Two
 B. Three
 C. Five
 D. Four

5. Which organ can regenerate itself?
 A. The kidneys
 B. The liver
 C. The spleen
 D. The appendix

6. Which of the following is NOT part of the digestive system?

 A. The stomach C. The esophagus
 B. The gallbladder D. The trachea

7. Where does insulin come from?
 A. The pancreas C. The stomach
 B. The liver D. The adrenal glands

8. What do lymph nodes do?
 A. Regulate the body's metabolism C. Filter out unwanted substances and cells
 B. Create new white blood cells D. Absorb nutrients from food

9. Which of the following is true?
 A. Arteries carry blood away from the heart C. Veins carry blood away from the heart
 B. Arteries carry blood to the heart D. Veins carry blood to the lungs

10. The Achilles tendon is located in the:
 A. Elbow C. Shoulder
 B. Knee D. Heel

Score Guide

1. A=5, B=0, C=0, D=0 2. A=0, B=5, C=0, D=0 3. A=0, B=0, C=5, D=0
4. A=0, B=0, C=0, D=5 5. A=0, B=5, C=0, D=0 6. A=0, B=0, C=0, D=5
7. A=5, B=0, C=0, D=0 8. A=0, B=0, C=5, D=0 9. A=5, B=0, C=0, D=0
10. A=0, B=0, C=0, D=5

Your Total Score _____

Results

0-15 **This is called a hand**

You know the big ones, but you could use a refresher about the systems of the body. You'll live in it all your life, so get to know it!

20-35 **Put on your smarty pants**

Either you have a great memory, or you watch a lot of medical dramas, because you've got a solid grasp of anatomy.

40-50 **What a left brain you have**

Biology is clearly your bag, because you know a wide range of anatomical words from the basics to the more fancy, medical terms.

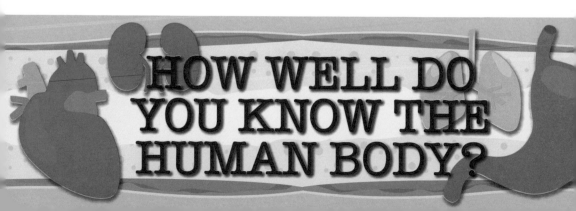

HOW WELL DO YOU KNOW THE HUMAN BODY?

They're printed on t-shirts and coffee mugs. They're fodder for inside jokes and spice up a conversation, but can you identify what movies your favorite lines came from?

1. "Frankly, my dear, I don't give a damn."
 A. The Big Sleep
 B. Bridget Jones' Diary
 C. Gone with the Wind
 D. Pride and Prejudice

2. "I'm gonna make him an offer he can't refuse."
 A. The Godfather
 B. Goodfellas
 C. On the Waterfront
 D. Guys and Dolls

3. "Here's looking at you, kid."
 A. The Philadelphia Story
 B. Sunset Boulevard
 C. Casablanca
 D. The African Queen

4. "Go ahead, make my day."
 A. Taxi Driver
 B. Sudden Impact
 C. Cool Hand Luke
 D. Dirty Harry

5. "Love means never having to say you're sorry."
 A. Roman Holiday
 B. It Happened One Night
 C. It's a Wonderful Life
 D. Love Story

6. "Fasten your seatbelts. It's going to be a bumpy night."
 A. All About Eve
 B. Bringing Up Baby
 C. Wuthering Heights
 D. The Maltese Falcon

7. "I love the smell of napalm in the morning."
 A. Good Morning Vietnam
 B. Apocalypse Now
 C. The Bridge of the River Kwai
 D. All Quiet on the Western Front

8. "You can't handle the truth!"
 A. Jerry Maguire
 B. Minority Report
 C. A Few Good Men
 D. Risky Business

9. "Why don't we pretend he didn't die? Just for a bit!"
 A. What About Bob?
 B. Caddyshack
 C. Groundhog Day
 D. Weekend at Bernie's

10. "As you wish."
 A. Cinderella
 B. The Princess Bride
 C. The Wizard of Oz
 D. Citizen Kane

Score Guide
1. A=0, B=0, C=5, D=0
2. A=5, B=0, C=0, D=0
3. A=0, B=0, C=5, D=0
4. A=0, B=5, C=0, D=0
5. A=0, B=0, C=0, D=5
6. A=5, B=0, C=0, D=0
7. A=0, B=5, C=0, D=0
8. A=0, B=0, C=5, D=0
9. A=0, B=0, C=0, D=5
10. A=0, B=5, C=0, D=0

Your Total Score _____

Results

0-15 **Plan a marathon of your favorites**

You like to watch movies, but you rarely watch the same ones over and over again. Watching your favorites again will (1) guarantee you'll enjoy them and (2) help you commit the great lines to memory.

20-35 **Do some genre hopping**

You tend to stick to a certain kind of movie. Take recommendations from friends and family for some movies outside your comfort zone. Your new favorite may be waiting for you where you least expect it!

40-50 **You're that person at the party**

...The awesome one, that is. You always have the right line to add to conversation no matter who you're talking to. You also give great tips to people looking to find a movie they'll like. You love the classics, but you also check out new releases, and you never miss the Oscars on TV.

TRICKY
Game of Titles

Whether you read a lot of books or prefer to catch the movie, this fill-in-the-blank quiz will test your recall.

1. The Call of the _____
 A. Wild
 B. Stars
 C. Wildman
 D. Soldier
 E. None of the above

2. One Hundred Years of _____
 A. War
 B. Solitude
 C. Peace
 D. Rain
 E. B and C

3. The Chronicles of _____
 A. Narnia
 B. Riddick
 C. Exandria
 D. A and B
 E. A, B and C

4. Duma _____
 A. Clay
 B. Arkansas
 C. Tima
 D. Key
 E. None of the above

5. Fast _____ at Ridgemont High
 A. Cars
 B. Times
 C. Track
 D. and Furious
 E. A and C

6. A _____ in Time
 A. Wrinkle
 B. Stitch
 C. Ripple
 D. A and B
 E. B and C

7. Sense and _____
 A. Nonsense
 B. Fury
 C. Sound
 D. Sensibility
 E. Character

8. Bridget Jones' _____
 A. Diary
 B. Problem
 C. Baby
 D. War
 E. A and C

9. The _____ in Our Stars
 A. Message
 B. Picture
 C. Fault
 D. Fire
 E. None of the above

10. The Left Hand of _____
 A. Light
 B. Darkness
 C. God
 D. B and C
 E. None of the above

Score Guide

1. A=5, B=0, C=0, D=0, E=0 2. A=0, B=5, C=0, D=0, E=10 3. A=5, B=5, C=5, D=10, E=15
4. A=0, B=0, C=0, D=5, E=0 5. A=0, B=5, C=0, D=0, E=0 6. A=5, B=0, C=0, D=10, E=0
7. A=0, B=0, C=0, D=5, E=0 8. A=5, B=0, C=5, D=0, E=10 9. A=0, B=0, C=5, D=0, E=0
10. A=0, B=5, C= 5 0, D=10, E=0

Results

0-10 Not so total recall

You prefer to live in the real world. You keep up with current events and watch TV, but you're not one to sit still for long enough to watch a lot of movies or read a lot of books. You'd rather be out doing things yourself than watch or read about pretend people doing things.

15-30 You'd rather watch the movie

You are a film buff and can quote all the famous lines, but reading isn't your thing. You know all the new releases that are coming up, and you look forward to seeing what role your favorite actors will take on next.

45-60 Book worm extraordinaire

You are an avid reader and you while you enjoy film adaptations, you pick at the details that are not accurate. You are rarely found without a book in your bag or loaded on your e-reading device.

65-80 Multi-media maven

You went above and beyond. And like a true Sherlock Holmes, you even out-witted the tricky ones and spotted the difference between a lesser-known title and a red herring.

Shakespeare-ism insult, sea creature, or sports word?

1. Is a "frilled shark" a Shakespearean insult, a sea creature, or a sports term?
 A. Shakespearean insult
 B. Sea creature
 C. Sports term

2. Is "codswallop" a Shakespearean word, sea creature, or sports term?
 A. Shakespearean insult
 B. Sea creature
 C. Sports term

3. Is a "fartlek" a Shakespearean word, sea creature, or sports term?
 A. Shakespearean insult
 B. Sea creature
 C. Sports term

4. A "full nelson" takes place in:
 A. A fight scene in Hamlet
 B. A wrestling ring
 C. An aquarium

5. A "wunderpus" is:
 A. A rare species of octopus
 B. An insult in *A Midsummer Night's Dream*
 C. A football play

6. A "poisonous bunch-backed toad" is:
 A. A resident of a Louisiana swamp
 B. An insult from Richard III
 C. Mike Ditka's favorite heckle

7. A fish that can stick itself to a rock is a:
 A. Reverend vice
 B. Gambit
 C. Spiny lumpsucker

8. A difficult situation named after a damp or soft playing field is called a:
 A. Sticky wicket
 B. Anemone
 C. Plague sore

9. A particularly gross insult from *Henry IV* is:
 A. Low blow
 B. Greasy tallow-catch
 C. Leaf slug

10. To "catch a crab" means to:
 A. Be at a loss for words
 B. Pull up a lobster trap with no lobsters in it
 C. Flip a rowing oar so it's parallel with the water

Answer Key

1. B – Frilled sharks prefer to stay below 5,000 feet.

2. A – Codswallop means "nonsense".

3. C – A fartlek is a Swedish training method.

4. B – A full nelson involves pinning the opponent's arms up over their head from behind.

5. A – A wunderpus photogenicus lives in the shallow waters near Bali.

6. B – Act 1, Scene 3

7. C – The pelvic fins of the spiny lumpsucker have adhesive discs.

8. A – We feel this needs no explanation.

9. B – Act 2, Scene 4

10. C – An especially violent crab can pull a rower from his or her seat.

Shakespeare-ism insult, sea creature, or sports word?

WHAT **PARTY GAME** ARE YOU?

It's one thing to be the life of the party, it's another to be a walking party game! Which classic game are you?

1. How would you describe your personality?
 A. Outgoing
 B. Flirty
 C. Serious
 D. Adventurous
 E. Laid back

2. When invited to a party what do you normally do?
 A. Socialize and talk to everyone
 B. See if there is someone I like and find a way to chat
 C. Find a corner and observe
 D. Be open to anything that may happen
 E. I hang out and listen to the music and talk with a few people

3. What type of hobby would you most likely try?
 A. Team sports
 B. Photography or poetry
 C. Golf or archery
 D. Skydiving
 E. Swimming or surfing

4. How often do you hang out with your friends?
 A. Almost every day
 B. I prefer to hang out with one special person
 C. I like to spend time alone
 D. When the mood arises
 E. Not very often but we always have fun

5. How do you feel about parties?
 A. I love them
 B. They're great places to meet new people
 C. I'm not a big fan
 D. I like them when they're fun and spontaneous
 E. I can take them or leave them

6. What is your favorite style music to dance to?
 A. Anything upbeat
 B. Slow and groovy
 C. I'm not a fan of dancing
 D. Latin
 E. Top 40 hits

7. What do you think makes a party fun?
 A. Lots of people
 B. Party games
 C. Good food
 D. Cool location
 E. Good vibe

8. What type of game is your favorite?
 A. Acting or action game
 B. A flirty game
 C. A strategic game
 D. A game that brings out the unexpected
 E. A guessing game

9. What is your favorite party food?
 A. Buffalo wings
 B. Sugary sweets
 C. Pretzels or chips
 D. Veggies and fruit platters
 E. Pizza

10. What is the most memorable thing you've ever done at a party?
 A. Karaoke
 B. Kissed someone for the first time
 C. Nothing comes to mind
 D. Danced on a table
 E. Fell asleep

Score Guide

1. A=1, B=2, C=3, D=4, E=5 **2.** A=1, B=2, C=3, D=4, E=5 **3.** A=1, B=2, C=3, D=4, E=5
4. A=1, B=2, C=3, D=4, E=5 **5.** A=1, B=2, C=3, D=4, E=5 **6.** A=1, B=2, C=3, D=4, E=5
7. A=1, B=2, C=3, D=4, E=5 **8.** A=1, B=2, C=3, D=4, E=5 **9.** A=1, B=2, C=3, D=4, E=5
10. A=1, B=2, C=3, D=4, E=5

Your Total Score _____

Results

10-17 Charades

You are the most social guest, the one all the other guest gravitate to. The party is not the same without you. People find you easy to talk to and always invite you to their shindigs. You love to tell stories and are very engaging with everyone you meet.

18-25 Spin the Bottle

You like parties, but for you they are a chance to see your crush or spend time with someone you really like. Your flirty nature gets you noticed and you hope to use this party game as a chance to get closer to the one you seek. You are not shy about your motives.

26-33 Poker

You are the serious and quiet guest at the party. You usually go for the food, and you tend to stick to the periphery and observe rather than get into the mix. You interact but only with people you find interesting. You don't really do small talk, so you prefer to socialize when you can have a real conversation with someone.

34-41 Truth or Dare

You love the unexpected and unpredictable. While you love a good party, it needs to be exciting to keep you interested. You are easily bored, but if the party is good you're the one who gets the crowd going. Spontaneity is your middle name.

42-50 Pictionary

You are easy going and take things as they come. You like parties, but you usually get there late. You prefer to have a smaller group of more intimate friends rather than a large, loud, over crowded party. You like to socialize with your inner circle and get to know new people in smaller numbers.

WHAT KIND OF PET WOULD YOU BE?

Do you ever look at a domestic animal and think, "That's the life"? If you could trade places with a pet, what kind of animal would you be?

1. Would you rather:
 A. Climb a tree
 B. Sing a song
 C. Run as fast as you can
 D. Take a nap
 E. Go swimming

2. How messy are you?
 A. I'm pretty tidy
 B. I don't clean up after myself
 C. Mud!
 D. I'm fastidious
 E. I'm self-cleaning

3. Would you rather eat:
 A. Chicken wings
 B. Leafy greens
 C. Nuts
 D. Beef jerky
 E. Sushi

4. How do you feel about water?
 A. I hate being wet
 B. I could live in it
 C. Cannonball!
 D. Great for cooling off
 E. Meant for drinking and bathing only

5. Pick an activity at the gym:
 A. The climbing wall
 B. Pilates
 C. Swimming laps
 D. I prefer outdoor activities
 E. I'd fly if I could

6. Choose a home:
 A. Penthouse apartment
 B. Tree house
 C. House boat
 D. A library
 E. A small house

7. How would your friends describe you?
 A. Outgoing
 B. Eccentric
 C. Passionate
 D. Independent
 E. Low-key

8. How would you describe yourself?
 A. High-maintenance
 B. Independent
 C. Like being taken care of
 D. Low-maintenance

9. How do you show your feelings?
 A. I keep them to myself
 B. I shout them from the rooftops
 C. With hugs and adoration
 D. I show affection gladly, but I also need time alone
 E. By keeping you company

10. What do you hate?
 A. Cold
 B. Quiet
 C. Being alone
 D. Crowds
 E. Sharks

Score Guide

1. A=1, B=2, C=3, D=4, E=5 **2.** A=1, B=2, C=3, D=4, E=5 **3.** A=4, B=1, C=2, D=3, E=5

4. A=4, B=5, C=3, D=1, E=2 **5.** A=1, B=4, C=5, D=3, E=2 **6.** A=2, B=1, C=5, D=4, E=3

7. A=3, B=1, C=2, D=4, E=5 **8.** A=1, B=4, C=3, D=5 **9.** A=1, B=2, C=3, D=4, E=5

10. A=1, B=2, C=3, D=4, E=5

Your Total Score _____

Results

10-17 Iguana

Iguanas are exotic, hate the cold, and aren't for everyone. A person has to really want an iguana. They love tropical climates and climbing trees. While they're a lot of work to own and not snugglers, they're unique and beautiful to behold.

18-25 Parrot

Parrots are colorful, intelligent, and full of sassafras. They are loud and messy, but their big personalities make them worth the work.

26-34 Dog

A dog loves company and isn't picky about the activity of choice. Walk? You bet. Sleep? Awesome. Dinner? Famished! Dogs are loyal to their packs, no matter what form the pack takes.

35-43 Cat

A cat is its own best friend. It loves to cuddle and play when the mood strikes, but when the mood swings the other way, it prefers to be alone. Kitty likes its owners to think it needs them, but really, they are just there to do the necessary scooping.

44-50 Goldfish

A goldfish requires the lowest possible maintenance. It is content to be shiny and swimming. As long as its tank is clean and food appears regularly, it is happy in its little mirror world.

WHAT KIND OF SHARK WOULD YOU BE?

Of all the world's creatures, sharks are some of the most fascinating and dramatic. Did you know there are over 400 types, and each one is totally different from the others? This begs the question... if you were a shark, what kind would you be?

1. How would you describe your eating habits?

 A. I love meat of all kinds. All food, really.

 B. I prefer fish and chicken, and I avoid red meat.

 C. I don't eat meat. I'm a vegan or vegetarian.

 D. I'm an omnivore, but shellfish is my fave.

 E. I'm an adventurous eater. I like trying exotic fare.

2. You're at a bar and a fight breaks out near you. What do you do?

 A. I don't like bars, so they can fight all they want. I'm not there.

 B. I jump in swinging whether the fight involves me or not.

 C. I bust out my karate moves.

 D. I stay out of the melee, but I stick around to watch.

 E. I try to break it up before someone gets hurt.

3. What is your favorite outdoor activity?

 A. A pick-up game with a group, like soccer or basketball

 B. A long hike on a trail

 C. Biking or running

 D. Football or rugby

 E. Bird watching or observing nature

4. Sushi night! What is your go-to order?

 A. Seaweed salad and a veggie roll

 B. Teriyaki

 C. Anything with tentacles

 D. Sashimi

 E. Give me crab and I'm happy

5. What is your exercise preference?

 A. Team sports

 B. Boxing

 C. 5Ks, 10Ks, and marathons

 D. Triathlons

 E. Long walks

6. If your friends could describe you in one word, what would it be?

A. Sensitive D. Social

B. Quiet E. Energetic

C. Aggressive

7. What do you do when you're at the beach?

A. Volleyball D. Recline in a beach chair with a book

B. People watch and look for shells E. All of the above

C. Frolic in the waves

8. When someone hurts someone you love, how do you respond?

A. I will find you... and I will kill you. D. Take them out to cheer them up

B. Call their friends and family to rally support E. Hugs!

C. Come right over with wine and ice cream
and activate listening mode

9. What famous fighter do you resemble or admire most?

A. Bruce Lee D. Martin Luther King, Jr. Freedom fighters
count, right?

B. Muhammed Ali E. George Foreman

C. Mike Tyson

10. What is your favorite solo activity?

A. Doing puzzles D. Playing games on my phone

B. Watching movies E. Yoga

C. Reading

Score Guide

1. A=2, B=1, C=3, D=4, E=5 **2.** A=4, B=2, C=1, D=5, E=3 **3.** A=5, B=4, C=1, D=2, E=3

4. A=3, B=2, C=5, D=1, E=4 **5.** A=5, B=2, C=4, D=1, E=3 **6.** A=4, B=3, C=2, D=5, E=1

7. A=1, B=5, C=4, D=3, E=2 **8.** A=2, B=5, C=4, D=1, E=3 **9.** A=1, B=4, C=2, D=3, E=5

10. A=4, B=2, C=3, D=5, E=1

Your Total Score _____

Results

10-17 Mako shark

You are built for speed and you travel light. The fastest of all sharks, Makos can swim up to 30mph and even leap up out of the water. You are agile and athletic, and you eat mostly fish so you're lean and mean.

18-25 Great white shark

Hi there, Jaws. You are most famous shark and also the most feared, which is no surprise since you're the largest meat eater in the world. You have the biggest teeth and can swallow a whole seal in one gulp, if that's your thing. Although you are an omnivore, you are often misunderstood. Really, you only bite a human now and then.

26-33 Whale shark

You're the "live and let live" type. Though you're the biggest living shark in the ocean, you are the opposite of a shark's aggressive, eating-machine reputation. You are passive and gentle, and you would never bite another living thing. Whale sharks are vegans, eating only plankton, and though they're bigger than great white, they have tiny teeth.

34-41 Nurse shark

You're the sensitive type. Nurse sharks tend to stay near the ocean floor. With the heightened nerve cells along their sides and sensors in their snouts, they can pick up vibrations most other beasts can't, even the heart beats and electrical charges from fish hidden in the sand.

42-50 Hammerhead shark

You are a pack animal and very observant. Hammerheads gather in large groups and are the most social sharks. Built with a broad, panoramic face, they swing their heads from side to side as they're swimming, giving them an extra wide view of their surroundings. You have more eclectic taste, so though you eat fish, your favorite food is squid.

WHAT KIND OF SHARK WOULD YOU BE?

WHAT NON-US CITY SHOULD YOU LIVE IN?

If you were to become an expat, where would you put down your roots? There are so many different cultures in which to immerse yourself. Which one fits your personality best?

1. What kind of climate do you prefer?
 A. Bring on the snow!
 B. Dry heat, please
 C. I like to experience all four seasons
 D. Rain clouds and green grass
 E. Hot and tropical

2. What of the following is most important to you?
 A. An active social life
 B. Variety and adventure
 C. Fulfillment
 D. Culture and the arts
 E. Having a good time
 F. Enjoying and preserving the environment

3. For a fun evening out, you like to:
 A. Head to the pub
 B. Ride in a gondola
 C. Club hop until they close
 D. Go salsa dancing
 E. Watch the Northern Lights
 F. How did we end up on a boat?

4. Pick a setting:
 A. The beach
 B. The opera
 C. A castle
 D. A bustling city street
 E. A mountain trail
 F. The spa

5. How do you like your jewelry?
 A. Anything gold
 B. An antique
 C. Silver or platinum
 D. Intricate patterns
 E. Colorful stones
 F. Sentimental value

6. Pick an adjective:
 - A. Romantic
 - B. Shiny
 - C. Fun
 - D. Jolly
 - E. Green
 - F. Feisty

7. Pick a food:
 - A. Hummus
 - B. Guacamole
 - C. Fish
 - D. Bangers and mash
 - E. Pasta
 - F. Well-seasoned beef

8. Pick an activity:
 - A. Soccer
 - B. Cycling
 - C. Walking
 - D. Dancing
 - E. Boating
 - F. Pilates

9. What quality do you like in a home?
 - A. A high-rise
 - B. A gorgeous view
 - C. Smart home capability
 - D. Proximity to activities
 - E. The hum of life around me
 - F. A relaxed atmosphere

10. I like to travel _____.
 - A. Far and wide
 - B. Where there's a lot to do
 - C. In luxury
 - D. In an eco-friendly and sustainable way
 - E. Where the food is best
 - F. Where the people are friendly

Score Guide

1. A=1, B=4, C=3, D=2, E=5 **2.** A=4, B=6, C=3, D=2, E=5, F=1 **3.** A=2, B=3, C=4, D=5, E=1, F=6
4. A=5, B=3, C=2, D=6, E=1, F=6 **5.** A=4, B=2, C=1, D=5, E=6, F=3 **6.** A=3, B=4, C=6, D=2, E=1, F=5
7. A=4, B=5, C=1, D=2, E=3, F=6 **8.** A=6, B=1, C=2, D=5, E=3, F=4 **9.** A=4, B=3, C=1, D=2, E=5, F=6
10. A=2, B=6, C=4, D=1, E=3, F=5

Your Total Score _____

Results

10-17 Stockholm, Sweden

Stockholm is all about renewability and sustainability, and setting an inspiring example for the rest of the world. You love to be active and eat light, which works perfectly with the fish, berries and crispy breads prominent in Swedish food. If you like the cold and thrive in the winter, Stockholm's invigorating and dry climate is perfect for you.

18-26 London, England

London is the perfect balance between the new and the old. From Shakespeare, to Sunday roast at the pub, to the London Eye, there's something for all your sensibilities. Let's face it, you're an anglophile at heart. You don't even mind the rain. London is also a hub to the rest of the world, so you can travel to and from it easily.

27-35 Venice, Italy

Venice is steeped in ancient history and charm. With its distinct canals and architecture, no other city looks quite like it. In Venice, you get the full range of weather from hot, humid summers to snowy winters. And did we mention the food? You are romantic and at times stubborn, but some people call that passionate.

36-43 Dubai, UAE

Present-day Dubai is a young city full of lots of expats and home to the Burg Khalifa—currently the tallest building in the world. If you love the night life and all things shiny, Dubai is the city for you. It is built for luxury and is a great place to buy gold and visit the spa. And when you're in the mood for some natural beauty, the surrounding desert is there waiting.

42-50 Puerta Vallarta, Mexico

Why shouldn't life be a beach? And why should there every be winter if you can avoid it? Puerta Vallarta is friendly, welcoming, and warm. It's like spending your life on vacation. You love the Latin lifestyle—the music, the food, and the hot weather.

42-50 Cape Town, South Africa

You're a laid-back kind of person, and you like a bit of the unknown. Cape Town has a little bit of everything—from beaches, to harbors, to mountains, to an urban center. It's hard to get bored there. Because it has had so many influences throughout its history, it doesn't even have one signature style of cooking. No matter how long you explore there, you'll keep finding new things.

WHICH 90s TV SHOW SHOULD YOU BINGE WATCH?

Whether you're re-watching a favorite show from your youth or watching a popular show for the first time, 90s TV is comfort food for the brain. The nostalgia, the irony, and seeing the actors you love early in their careers make binge-streaming a fun way to unwind alone or with friends. Which show should you start with?

1. What age of characters do you prefer?
 A. Teenagers
 B. Adults in their 20-30s
 C. A mix of young and old

2. What kinds of stories do you prefer?
 A. Science fiction
 B. True crime
 C. Romance
 D. Comedy
 E. Political or historical drama

3. Choose a location:
 A. California
 B. New York
 C. Outer space
 D. Washington, DC

4. I like a show that makes me:
 A. Gasp!
 B. Laugh
 C. Wonder
 D. Think

5. Choose a musical style:
 A. Hip hop
 B. Pop
 C. Rock
 D. Experimental
 E. Classical

6. Choose a movie:
 A. Stargate
 B. Bad Boys
 C. The Notebook
 D. When Harry Met Sally
 E. The American President
 F. Signs

7. What was your favorite 90s style?
 A. Shoulder pads/Pleated pants
 B. Feathered bangs/Double denim
 C. Backwards hats
 D. "The Rachel"/Sleeveless denim vests
 E. Mock turtle necks/Bold patterns
 F. Blazers

8. Who were you in high school?
 A. Class president
 B. A nerd
 C. The popular kid
 D. Class clown
 E. The awkward invisible kid

9. Choose a catch phrase:
 A. The truth is out there
 B. Decisions are made by those who show up
 C. How you doin'?
 D. Mind ya business
 E. Are we having fun yet?
 F. Make it so

10. Where do you like to hang out?
 A. A pool house
 B. A coffee house
 C. A fancy, new house
 D. A haunted house
 E. The White House
 F. A house on a holodeck

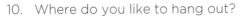

Score Guide

1. A=2, B=4, C=6 **2.** A=5, B=4, C=1, D=3, E=6 **3.** A=1, B=3, C=4, D=6

4. A=1, B=3, C=4, D=6 **5.** A=2, B=1, C=3, D=4, E=6 **6.** A=5, B=2, C=1, D=3, E=6, F=4

7. A=6, B=1, C=2, D=3, E=5, F=4 **8.** A=6, B=5, C=1, D=2, E=3 **9.** A=4, B=6, C=3, D=2, E=1, F=5

10. A=2, B=3, C=1, D=4, E=6, F=5

Your Total Score _____

Results

10-18 Beverly Hills 90210

For teenage drama and catharsis, nothing beats 90210. It was so popular that a new edition was brought back by popular demand and ran for five more seasons. If you love to watch the friendships, romances and betrayals unfold, watch *Dawson's Creek* or *Sweet Valley High* next.

19-27 The Fresh Prince of Bel Air

The Fresh Prince made Will Smith famous for good reason. This family-based comedy was packed with talented and hilarious actors and ran for six seasons. You know the theme song is stuck in your head now, anyway, so enjoy! If you like this show, try *Home Improvement* or *Family Matters*.

28-36 Friends

One of the most quoted shows of the 90s, *Friends* follows six quirky New Yorkers through the everyday challenges of adulthood—in a funny way. Friends ran for ten seasons, so there are plenty of episodes to keep you busy. When you're done, check out *Will and Grace* or *Seinfeld*.

37-44 The X-Files

The X-Files captured the imagination by injecting science fiction into the normal, present day. Aliens aren't just for outer space anymore! If this is your kind of show, check out *Buffy the Vampire Slayer* or *Charmed* for more nineties-tastic fantasy.

45-52 Star Trek: The Next Generation

TNG made Star Trek cool again with even more beloved characters than the original series. Whether you're an outer space fan or not, it at least brought Patrick Stewart to American audiences. For more kitschy futuristic fun, catch *Seaquest* or *Stargate SG1*.

53-60 The West Wing

The West Wing is making a big comeback already with its immortal characters, smart but funny dialog, and inspiring political message. For viewers who like something intellectual and humorous, *Frasier* and *Ally McBeal* are also musts.

WHAT *pizza topping* ARE YOU?

1. What is your favorite place to get pizza?
 A. An Italian restaurant
 B. A chain restaurant
 C. A little bistro
 D. A local pizza joint
 E. A pub or all-American restaurant

2. What is your biggest restaurant pet peeve?
 A. Being too fancy
 B. Food that is too complicated
 C. A boring atmosphere
 D. Not enough vegetarian/vegan choices
 E. Ingredients that aren't fresh or local

3. What is your favorite non-pizza food?
 A. Macaroni and cheese
 B. Cheeseburger
 C. Fusion tacos
 D. Seasonal and sustainable roasted veggies
 E. French fries

4. Where do like to meet up with people?
 A. Happy hour
 B. A coffee shop
 C. A sports bar
 D. The movies
 E. A fro-yo place

5. Choose an appetizer:
 A. Buffalo wings
 B. Mozzarella sticks
 C. Kebabs
 D. Stuffed mushrooms
 E. Spring rolls

6. How do you say hello?
 A. Aloha
 B. Hey stranger!
 C. Bonjour
 D. (Fist bump)
 E. Hello

7. Choose a fictional place to live:
 A. Metropolis
 B. Gotham City
 C. The Shire
 D. Narnia
 E. Atlantis

8. Choose the most annoying thing:
 A. The word "moist"
 B. Oxford commas
 C. Loud chewing
 D. Being late all the time
 E. Excessive selfie taking

9. Choose a sport:
 A. Surfing
 B. Nascar
 C. Baseball
 D. Soccer
 E. Quidditch

10. How is all this pizza talk making you feel?
 A. I'm hungry
 B. I already phoned in my order
 C. Stop toying with me and give me my results
 D. I need pizza right now
 E. Like calling my friends and making dinner plans SOON

Score Guide

1. A=1, B=4, C=3, D=5, E=2 **2.** A=2, B=1, C=5, D=4, E=3 **3.** A=1, B=2, C=5, D=3, E=4

4. A=4, B=1, C=2, D=5, E=3 **5.** A=2, B=1, C=5, D=4, E=3 **6.** A=5, B=4, C=3, D=2, E=1

7. A=2, B=1, C=4, D=3, E=5 **8.** A=4, B=3, C=1, D=2, E=5 **9.** A=5, B=2, C=1, D=4, E=3

10. A=1, B=4, C=3, D=2, E=5

Your Total Score _____

Results

10-17 Extra cheese

No need to mess with perfection. You're a fan of the classics. A big ol' slice of cheese pizza will do you just fine. You care more about a well-made crust and tasty sauce.

18-25 Meat lovers

Bring on the pepperoni, sausage, meatball, and bacon. A touch of barbecue or bleu cheese wouldn't go amiss, either. Veggies are meant for salad, not pizza.

26-33 Roasted garlic, prosciutto and fennel

You're a fancy gourmet and you like to experiment. Why have the same old thing when you can update it with fresh, local ingredients and have a real culinary experience.

34-41 Veggie

Mushroom-tastic! You like yours with peppers, olives, or onions. Throw in some slices of fresh tomato on top of the sauce, too. It counts as a serving of vegetables if it's covered in cheese, right?

42-50 Hawaiian

You prefer the sweet and juicy flavors of pineapple and ham on your Italian delicacies. You don't often go with the group trend and like to be the oddball.

WHAT pizza topping ARE YOU?

WHAT MOVIE GENRE FITS YOUR personality?

If your life were a movie, what kind would it be?

1. What kinds of stories do you like?
 A. True stories
 B. Exciting stories
 C. Funny stories
 D. Weird stories
 E. Stories with subtitles

2. How do you feel about being scared?
 A. It's fun!
 B. Scary parts make the happy parts happier.
 C. It should be avoided. Life is scary enough.

3. Who would you want to be for Halloween?
 A. A jedi
 B. A super hero
 C. A president or influential person
 D. A queen or king
 E. A traditional outfit from another country

4. Choose an author:
 A. Jane Austen
 B. Jon Krakaur
 C. Gabriel García Márquez
 D. James Patterson
 E. Philip K. Dick

5. How many Star Wars movies have you seen?
 A. I have them all memorized
 B. I've seen most of them and they're ok
 C. I've seen the original three once or twice
 D. I haven't seen any of them from start to finish
 E. I've seen them all

6. How do you feel about the movie, Titanic?

 A. I love it.
 B. It's full of inaccuracies.
 C. The ending ruined it. Why let go?
 D. Never saw it.
 E. I'm not a fan.

7. Choose an onscreen couple:

 A. Elizabeth and Darcy
 B. Han and Leia
 C. Rocky and Adrian
 D. Fred and Ginger
 E. Bonnie and Clyde

8. Which of the following describes you?

 A. A little nerdy. Ok, more than a little.
 B. Bad grammar makes me twitch.
 C. I speak more than one language.
 D. I hate being bored.
 E. I'm an optimist.

9. Who was the best James Bond?

 A. Daniel Craig
 B. Sean Connery
 C. Pierce Brosnan
 D. Timothy Dalton
 E. Roger Moore

10. Choose a Johnny Depp role:

 A. Edward Scissorhands
 B. Chocolat
 C. Pirates of the Caribbean
 D. What's Eating Gilbert Grape?
 E. The Ninth Gate

Score Guide

1. A=1, B=4, C=3, D=5, E=2 **2.** A=5, B=3, C=1 **3.** A=5, B=4, C=1, D=3, E=2
4. A=3, B=1, C=2, D=4, E=5 **5.** A=5, B=3, C=2, D=1, E=4 **6.** A=3, B=1, C=2, D=5, E=4
7. A=2, B=5, C=4, D=3, E=1 **8.** A=5, B=1, C=2, D=4, E=3 **9.** A=4, B=1, C=3, D=5, E=2
10. A=3, B=2, D=4, D=1, E=5

Your Total Score _____

Results

10-18 Documentary

You love to dive into a topic, think of questions, and find experts to answer them. You love answers, but you also love when a question leads to a more interesting question.

19-27 Foreign

You are aware of the world outside the familiar. You love languages, cities in other countries, and the romance of the unfamiliar.

28-35 Romantic comedy

You're a people person, and other people like to be around you. You like time alone, but you balance it with time spent with family and good friends.

36-42 Action

You love to be busy and aren't a big fan of staying still. You like excitement and suspense, and perhaps a clever catch phrase now and then.

43-50 Science fiction

You're a "what if?" kind of person. What if we were capable of exploring other planets and galaxies? What if robots took over the Earth? Wouldn't it be cool if...?

WHICH PLANET SHOULD YOU LIVE ON?

Imagine it's thousands of years from now and all the planets are colonized. Which one would be the best fit for your tastes?

1. You live in the jungle. Which animal are you?
 - A. Orangutan
 - B. Tiger
 - C. Chameleon
 - D. Python
 - E. Sloth

2. What is the most important quality in outer space?
 - A. Bigness
 - B. Proximity to the sun
 - C. Rings!
 - D. Being mistaken for a moon
 - E. Traces of water

3. How tall are you?
 - A. Average height
 - B. Tall
 - C. Short
 - D. It's all in how you wear it

4. Do you have a big family?
 - A. A small close family but not much extended family
 - B. Not much family
 - C. More loud than big
 - D. I have a large, always growing family
 - E. Not big, but not small either

5. Are you an outgoing person?
 - A. People tend to come to me
 - B. Leave me alone
 - C. Most of the time
 - D. It depends on my mood
 - E. Yes, very

6. Which do you wear the most:
 A. Orange
 B. Red
 C. Khaki
 D. Black
 E. Accessories

7. Do you look forward to your birthday?
 A. More like birthday month!
 B. I plan the party way in advance
 C. I'd rather forget about it
 D. Yes, but I don't always celebrate
 E. I love surprise parties

8. What is your favorite natural formation?
 A. Volcanoes
 B. Painted deserts
 C. Clouds
 D. Hot springs
 E. Glaciers

9. If you were a god, what would you be the god of?
 A. Love
 B. The underworld
 C. War
 D. Light
 E. Wealth

10. What's the best part about outer space?
 A. Hanging with moons
 B. The unknown
 C. The atmosphere
 D. Aliens
 E. The quiet

Score Guide

1. A=1, B=3, C=2, D=4, E=5 **2.** A=3, B=1, C=4, D=5, E=2 **3.** A=1, B=3, C=5, D=4
4. A=2, B=5, C=1, D=3, E=4 **5.** A=4, B=5, C=2, D=1, E=3 **6.** A=1, B=2, C=3, D=5, E=4
7. A=2, B=3, C=5, D=4, E=1 **8.** A=2, B=4, C=3, D=1, E=5 **9.** A=1, B=5, C=2, D=3, E=4
10. A=3, B=4, C=1, D=2, E=5

Your Total Score _____

Results

10-17 Venus

Venus is Earth's warmest, closest neighbor. Though it's named after the goddess of love, it has a thick atmosphere and spins in the opposite direction to most other planets. You have a strong, passionate personality and you voice your views whether people agree with you or not.

18-25 Mars

Little red Mars is similar to Earth in that it has weather, volcanoes, and polar ice caps and canyons. There's evidence it experienced floods in the ancient past, which makes it the go-to imaginary home planet of extra-terrestrials. You love variety and Mars is a perfect fit for your adventurous personality.

26-33 Jupiter

Named for the king of the Roman gods, Jupiter is large and in charge and located right in the middle of the solar system. Its distinct stripes are actually windy clouds, and it boasts at least 50 moons with more waiting to be confirmed. You are a leader and quite comfortable in a room full of people.

34-41 Saturn

Saturn is unique because of its rings, but it also has one of the most beautiful land-scapes in our solar system. The farthest planet than can be seen by the human eye, Saturn also holds a healthy dose of mystery. You love a good accessory, and people find you artistic and pleasantly aloof.

42-50 Pluto

Is Pluto really a planet or not? The debate has gone back and forth a few times, but you don't care. Its small size, cold darkness and long-distance commute are perfect for you. You're more of an introvert and not many people totally "get" you, but the ones who do are worth having around.

Just like movies, songs are true classics when you're still excited about them a generation after they're released. Put together your ideal action movie, and we'll tell you what song makes your rock and roll soul sing.

1. Choose a leading man:
 A. Matthew McConaughey
 B. Harrison Ford
 C. Matt Damon
 D. Brad Pitt
 E. Robert Downey, Jr.

2. Choose a leading lady:
 A. Gal Godot
 B. Angelina Jolie
 C. Jennifer Lawrence
 D. Sandra Bullock
 E. Uma Thurman

3. Choose a franchise:
 A. Marvel
 B. DC Comics
 C. Star Wars
 D. The Fast and the Furious
 E. Transformers

4. Choose a director:
 A. James Cameron
 B. John Woo
 C. Quentin Tarantino
 D. Stephen Spielberg
 E. Ron Howard

5. Choose a setting:
 A. A big metropolis
 B. A desert
 C. A football field
 D. A small town
 E. The open road

6. Choose a genre:
 A. Post-apocalypse
 B. Alien invasion
 C. Sports
 D. Super heroes
 E. Action comedy

7. Choose a villain:
 A. Inner demons
 B. Power-hungry baddie
 C. Terrorists
 D. Bad guy seeking revenge
 E. Space robots

8. How does the hero respond to threats?
 A. With a clever remark
 B. With guns
 C. With a plan
 D. Speeding away in a sports car
 E. With mixed martial arts

9. Choose a sidekick:
 A. A friend
 B. A witty stranger
 C. A coward
 D. A cab driver
 E. An equal

10. Choose a form of suspense:
 A. The sidekick is in cahoots with the enemy
 B. A bomb on a timer
 C. The sidekick leaves but comes through at the last minute
 D. The enemy is really on the side of good
 E. An elaborate car chase

Score Guide

1. A=5, B=2, C=3, D=4, E=1 **2.** A=1, B=4, C=3, D=5, E=2 **3.** A=3, B=1, C=2, D=4, E=5
4. A=3, B=1, C=2, D=4, E=5 **5.** A=2, B=5, C=1, D=3, E=4 **6.** A=2, B=5, C=1, D=3, E=4
7. A=4, B=1, C=2, D=3, E=5 **8.** A=5, B=1, C=3, D=4, E=2 **9.** A=5, B=2, C=3, D=4, E=1
10. A=3, B=1, C=5, D=2, E=4

Your Total Score _____

Results

10-17 We Will Rock You

Stomp, stomp, CLAP. Stomp, stomp, CLAP. This Queen hit is all about confidence. You can't not get pumped when you hear it.

18-25 We Didn't Start the Fire

This Billy Joel classic is all about nostalgia and the cultural events that changed the world. Anyone who knows all the words deserves this as their anthem.

26-33 Don't Stop Believing

Hold onto that feeling! This Journey standard captures the hope of youth and the importance of human connection.

34-41 Born to Run

This classic by "The Boss" appeals to the wanderer in all of us. It just makes you want to get in the car and drive.

42-50 Sweet Home Alabama

Where the skies are so blue! This Lynyrd Skynyrd song is about getting back to your roots and knowing where you belong.

WHAT PROFESSIONAL SPORT SHOULD YOU PLAY?

Based on your preferences and skills, if you were to go into professional sports, which one would be best for you?

1. How do you feel about running?
 A. Nope. I'd rather walk
 B. It's good exercise but hard on the knees
 C. I like short sprints
 D. I love it

2. Choose your favorite board game:
 A. Chess
 B. Jenga
 C. Hungry Hungry Hippos
 D. Monopoly
 E. Cards Against Humanity
 F. Pictionary

3. What is the best part of playing sports?
 A. Doing what I've loved since I was a kid
 B. Pushing myself beyond my limits
 C. A winning strategy
 D. Defeating my opponent whatever it takes
 E. Leading my team toward a common goal
 F. The energy and excitement of the live game

4. What is the most important quality in an athlete?
 A. Physical strength and stamina
 B. Always improving form and technique
 C. Speed
 D. Teamwork
 E. Winning the mental game
 F. Captivating the fans

5. What is your greatest weakness?
 A. I'm not fast
 B. I am a lone wolf
 C. I'm in my head a lot
 D. I don't have much stamina
 E. I get hurt a lot
 F. I love the limelight

6. When you're at the gym, what you do like best?
 A. Working with a trainer
 B. Lifting weights or doing CrossFit
 C. I prefer a walk outside
 D. Speed trials and agility training
 E. Hit the pool
 F. High intensity interval training (HIIT)

7. What is your favorite sports-related noise?
 A. Clattering helmets
 B. Cleats on the locker room floor
 C. The starting gun
 D. Sneakers squeaking on the court
 E. When the crowd goes quiet
 F. When the crowd goes wild

8. Who is your sports idol?
 A. Michael Phelps / Katie Ledecky
 B. Tiger Woods / Michelle Wie
 C. David Beckham / Hope Solo
 D. Andre Agassi / Serena Williams
 E. Emmitt Smith
 F. Babe Ruth

9. What is your favorite sporting event?
 A. The Olympics
 B. The Super Bowl
 C. The World Cup
 D. Wimbledon
 E. Masters Tournament
 F. The World Series

10. What is your favorite part of going to games?
 A. I prefer to watch on TV
 B. Cheering and booing
 C. Hotdogs and beer
 D. Tailgating

Score Guide

1. A=1, B=2, C=4, D=6 **2.** A=1, B=3, C=2, D=4, E=6, F=5 **3.** A=4, B=3, C=1, D=5, E=2, F=6
4. A=5, B=1, C=3, D=4, E=2, F=6 **5.** A=1, B=3, C=2, D=4, E=5, F=6 **6.** A=4, B=5, C=1, D=6, E=3, F=2
7. A=5, B=6, C=3, D=2, E=1, F=4 **8.** A=3, B=1, C=6, D=2, E=5, F=4 **9.** A=3, B=5, C=6, D=2, E=1, F=4
10. A=1, B=6, C=4, D=5

Your Total Score _____

Results

10-17 Golf

Your strengths are strategy, precision and technique. While you're competitive and you enjoy the mental challenge of the game, playing on a team and getting bashed around to get to the ball isn't your thing. You like to be outdoors and active as long as running isn't involved.

18-25 Tennis

You love to face off against an opponent and feed off of the drama and focus of tennis. Your own skill, strength and speed are essential, but so is reading and responding to those of your competition. When you play tennis, you represent only yourself and your country, and success or failure depend on you and you alone.

26-33 Swimming

You're strong and fast, and form is important to you. You like low-impact activities on and off of dry land. You enjoy being part of a team, but you also like to be in control of your own achievements and do your personal best without having to pass the ball to someone else. When you get it just right, swimming is the closest thing to flying.

34-42 Baseball

You love the sport and being on the team, whether you're the one up at bat or not. You also love the romance of being a part of the "American pastime". Baseball also gives you the chance to change it up and not do the same thing all the time. Since your body doesn't take as much of a beating as other professional sports, you can play professionally for longer.

43-51 Football

Football combines physical strength, speed, and strategy. Though there's a chance to stand out and be a star and a leader, you love to be a part of something bigger than yourself. When you're playing football, it's impossible to win the game on your own skills alone. You love leaning on a team and being leaned on.

52-60 Soccer

Soccer is a sport of perpetual motion with very little down time. The game doesn't stop and start as often other sports do, and you have to be constantly on your toes and ready to spring into action. This team sport requires the fitness of an athlete finesse of a dancer. Soccer also often leads to more world travel than other sports.

WHAT PROFESSIONAL SPORT SHOULD YOU PLAY?

Which Zodiac Sign Should You Really Be?

No matter when you were born, zodiac signs correspond to certain types of personalities. Does yours match your sign?

1. Which word best describes you in regards to your work?
 A. Over-achiever
 B. Dependable
 C. People person
 D. Idea person
 E. Confident
 F. Leader
 G. Challenge seeker

2. When you have a problem, what do you do first?
 A. Analyze it in detail
 B. Weigh the options
 C. Talk to someone about it
 D. Don't worry too much about it
 E. Freak out
 F. Smile and say, "Bring it on!"
 G. Keep it to myself until I have a handle on it

3. What role do you play in your family?
 A. Protector
 B. Advisor
 C. Comforter
 D. Storyteller
 E. Host
 F. Peacekeeper
 G. Breadwinner

4. What is the most important thing in a romantic relationship?
 A. Passion
 B. Adventure
 C. Love
 D. Harmony
 E. Respect
 F. Trust
 G. Honesty

5. Choose a priority:
 A. Accomplishments
 B. Self-improvement
 C. Independence
 D. Work-life balance
 E. Teamwork
 F. Creativity
 G. Leadership

6. It's time for lunch on a work day. What do you do?
 A. Make myself some lunch
 B. Ask whomever I'm with to have lunch with me
 C. Coordinate a meal for everyone
 D. Forget to eat

7. Your friends and family think you:
 A. Work too much
 B. Are very organized
 C. Spend too much time alone
 D. Are fun to be around
 E. Always come through
 F. Are the life of the party
 G. Are generous

8. How would you like to spend your retirement?
 A. Reading and pursuing hobbies I never had time for
 B. I'll never retire
 C. Volunteering
 D. Traveling and exploring
 E. Learning new things
 F. Taking up painting or photography
 G. Spending more time with family

9. What's the most important thing in a friendship?
 A. Laughter
 B. Loyalty
 C. Being there for each other no matter what
 D. Harmony
 E. Accepting each other for who you are
 F. Patience
 G. Learning from each other

10. When something makes you angry, what do you do?
 A. Bottle it up
 B. Keep calm
 C. Vent to someone
 D. Let it go
 E. Save your feelings for when you're alone
 F. React and express your anger right away
 G. Have a quick moment of anger, then calm down right away

Score Guide

1. A = 7, B = 6, C = 5, D = 4, E = 3, F = 2, G = 1

2. A = 7, B = 6, C = 5, D = 4, E = 3, F = 2, G = 1

3. A = 2, B = 1, C = 4, D = 3, E = 6, F = 5, G = 7

4. A = 2, B = 3, C = 4, D = 5, E = 6, F = 1, G = 7

5. A = 7, B = 6, C = 1, D = 5, E = 4, F = 3, G = 2

6. A = 1, B = 2, C = 3, D = 5, E = 4

7. A = 7, B = 6, C = 1, D = 4, E = 5, F = 3, G = 2

8. A = 6, B = 7, C = 5, D = 4, E = 2, F = 1, G = 3

9. A = 2, B = 4, C = 5, D = 1, E = 6, F = 7

10. A = 7, B = 6, C = 5, D = 4, E = 1, F = 3, G = 2

Your Total Score _____

Results

12-17 **Scorpio**

Scorpios are passionate, self-aware, and wise. They like alone time, but they are quick to stand up for people they love.

18-23 **Aries**

An Aries is courageous, a natural leader with lots of energy. They love a challenge or an opportunity to rise to an occasion.

24-29 **Leo**

Leos are proud, but confident enough to be relaxed and in charge. They are protective and generous with loved ones.

30-35 **Gemini**

A Gemini loves people and is charming and adventurous. They love learning new things.

36-40 **Pisces**

Pisces are likeable, energetic, sensitive, and passionate. They love to daydream and have great ideas, though they're not great at following them through.

42-48 Sagittarius

A Sagittarius is a happy, absent-minded, creative type. They love to travel and meet new people, and they don't like to be tied down to one place or path.

49-54 Aquarius

Aquarius is a communicative, people-oriented person. They are stubborn but forward-thinking in their views.

55-60 Cancer

Cancer the crab is emotional and doesn't like to be alone. They love to be part of group and have the security of family and friends around them.

61-66 Libra

Libra seeks balance, weighs options, and prefers peace and harmony in all aspects of their lives. They also have a strong sense of justice and doing what's right.

67-72 Taurus

The bull is grounded and dependable. Tauruses are loving and not easily provoked to anger or extremes of any kind.

73-78 Virgo

Virgo the perfectionist is practical, calm, and eager to help. They are quiet on the surface with a busy mind always going underneath.

79-84 Capricorn

Capricorns are driven, ambitious over-achievers. They are very detail-oriented and less forthcoming with emotions.

Which Zodiac Sign Should You Really Be?

Would you be a good scout?

The boy scouts and girl scouts teach survival, samaritanship, and self-confidence. If you were to become a scout, would you earn all the ribbons or just eat all the cookies?

1. How do you put up a tent?
 A. Pretend to be busy while someone else does it instead.
 B. Put the poles in the proper slots and stake it down.
 C. Keep the tarp in place underneath and read instructions to your fellow campers.

2. Choose a boy scout merit badge:
 A. Archery
 B. Emergency preparedness
 C. Citizenship in the World

3. A girl scout promises to:
 A. Respect myself and others
 B. Sell cookies
 C. Make the world a better place

4. A boy scout promises to:
 A. Keep myself physically strong
 B. Help people at all times
 C. Be at one with nature

5. Choose a girl scout merit badge:
 A. Primitive camper
 B. Good sportsmanship
 C. Think big

6. The ideal scout should be able to:
 A. Mentor other scouts
 B. Survive in the wilderness
 C. Set and achieve goals

7. How do you earn a camping badge?
 A. Be completely prepared for the journey
 B. Find a nearby hotel
 C. Leave no trace that you were there

8. How do you earn a detective badge?
 A. Read a detective novel
 B. Make invisible ink
 C. Set out clues for others to find

9. Choose a female role model:
 A. Carrie Fisher
 B. Michelle Obama
 C. Kim Kardashian

10. Choose a male role model:
 A. Neil Armstrong
 B. Michael Jordan
 C. Justin Timberlake

Score Guide

1. A = 1, B = 2, C = 3	**2.** A = 1, B = 2, C = 3	**3.** A = 3, B = 1, C = 2
4. A = 2, B = 3, C = 1	**5.** A = 1, B = 2, C = 3	**6.** A = 3, B = 1, C = 2
7. A = 3, B = 1, C = 2	**8.** A = 1, B = 2, C = 3	**9.** A = 2, B = 3, C = 1
10. A = 3, B = 2, C = 1		

Your Total Score _____

Results

10-16 Tenderfoot

Unfortunately, your vest wouldn't sport many badges. Roughing it just doesn't appeal to you, and you prefer to keep your own counsel.

17-24 Eagle

You know a lot of the essential scout skills, and you focus a lot on personal achievements like improving skills and earning badges.

25-30 Scoutmaster

Scouting is about more than skills. It's about teamwork and leadership. You not only know how to do things yourself, but you know how to help the group succeed together.

WHAT SHOULD YOU BE FOR HALLOWEEN?

You're never too old to dress up. A Halloween costume can be fun, expressive, or personal. Which kind of costume is right for you?

1. A Halloween costume should:
 A. Get a strong reaction
 B. Be scary, of course
 C. Make a statement
 D. Be silly or cute
 E. Express your interests

2. What does Halloween mean to you?
 A. It's like my Christmas
 B. A chance to be my favorite characters
 C. A holiday with a fascinating history
 D. The best party of the year
 E. A day to let my inner child play

3. Would you rather:
 A. Go to Comic Con
 B. Visit a historical site or home
 C. Go to the zoo
 D. Go to the circus
 E. Go to an escape game

4. What is your favorite Halloween activity?
 A. Watching scary movies
 B. Going to parties
 C. A spooky corn maze
 D. Trick or treating
 E. Putting up decorations

5. What is your favorite Halloween movie?
 A. Beetlejuice
 B. It's the Great Pumpkin, Charlie Brown
 C. Hocus Pocus
 D. Halloween
 E. Frankenstein

175

6. What scares you?

 A. Nothing
 B. Clowns
 C. Death
 D. Losing loved ones
 E. Heights

7. What do you do for trick-or-treaters?

 A. Give out candy
 B. Pretend not to be home
 C. Set up a haunted house
 D. Give out something more creative
 E. Answer the door in costume

8. Choose a Halloween treat:

 A. Candied apples
 B. Cupcakes
 C. Candy corn
 D. Fake eyeballs and brains
 E. Pumpkin baked goods

9. If you could be one non-human being, which would you be?

 A. A witch
 B. A mummy
 C. A vampire
 D. An angel
 E. A demon

10. Do you believe:

 A. Séances/psychics are real
 B. Ghosts exist
 C. Magic happens
 D. Animals communicate
 E. Urban legends are true

Score Guide

1. A=4, B=5, C=2, D=3, E=1 **2.** A=5, B=1, C=2, D=4, E=3 **3.** A=1, B=2, C=3, D=4, E=5

4. A=4, B=1, C=5, D=3, E=2 **5.** A=4, B=3, C=1, D=5, E=2 **6.** A=5, B=3, C=2, D=1, E=4

7. A=3, B=2, C=5, D=4, E=1 **8.** A=2, B=3, C=4, D=5, E=1 **9.** A=3, B=2, C=4, D=1, E=5

10. A=4, B=2, C=1, D=3, E=5

Your Total Score _____

Results

10-18 A comic book, movie or literary character

Wonder Woman, Superman and Harry Potter remain the most popular characters for cosplay. Dressing up as a character you love may help you discover people whose nerd factors match your own.

19-26 A politician or historical figure

A costume becomes a conversation starter when you dress as a real person you admire (or want to satirize). If you're someone who loves history and keeping up with current events, this is the right costume for you.

27-33 An animal

We're talking full body costume. A bunny, a dinosaur, a giraffe, you name it. These get great reactions from friends and strangers alike. Animal costumes are also the most neutral if you prefer to keep things benign and light.

34-41 A clown

A clown can be fun or scary depending on your personal spin and the reactions of those around you. Do you want to know which of your friends have clown phobias? Put on a clown costume and find out!

42-50 A zombie

Halloween is meant to be spooky. It's a day for ghosts, goblins, monsters and all things scary. If you love gore, makeup and masks, zombies are all the rage these days. It also gets you out of chit chat if you commit to your character!

WHICH FAMOUS DETECTIVE ARE YOU?

There are so many ways to be a detective, as long as the mystery is solved at the end, that is. The most beloved fictional sleuths are all remembered for very different reasons. Which one are you most like?

1. Are you male or female?

 A. Male

 C. Female

2. Why did you become a detective?

 A. To make a living in this dark, gritty world

 B. Because my curiosity compels me

 C. To help people solve their problems

 D. It's the perfect occupation for my superior mind

 E. Being a detective is my destiny, though I cause chaos along the way

 F. I find people and their motives so interesting

3. What is your secret weapon?

 A. My empathy

 B. I am a master of disguise

 C. Bourbon

 D. I let people underestimate me

 E. My commanding intelligence

 F. My curiosity

4. How do you keep your wits sharp?

 A. My assistant sneak attacks me to encourage constant vigilance

 B. Coffee

 C. I make a study of the human psyche

 D. By always listening to the people around me

 E. By staying actively involved in my community

 F. I'm a teenager. My wits are naturally sharp.

5. How do you get people to spill the beans?

 A. By being sweet and charming

 B. Sarcasm and a rough, intimidating exterior

 C. By accident, usually

 D. I make them feel heard and understood

 E. I ask them indirect but ultimately revealing questions

 F. I get them to gossip

6. How do you unwind at the end of a case?

 A. I am always wound

 B. Hanging out with my friends

 C. A drink and a cigar

 D. Have people over for dinner

 E. Constant vigilance!

 F. A nice cup of tea

7. Which movie would you rather watch?

 A. Waiting to Exhale

 B. Sisterhood of the Traveling Pants

 C. Driving Miss Daisy

 D. The Maltese Falcon

 E. Young Frankenstein

 F. A Beautiful Mind

8. If you weren't a detective, what would be your dream job?

 A. Psychologist

 B. Business owner

 C. Bartender

 D. Rodeo clown

 E. Countess

 F. Pro-bono lawyer

9. What kind of reading material do you prefer?

 A. Newspaper headlines

 B. Romance novels

 C. Magazines

 D. Comics

 E. Inspiring stories

 F. Essay collections

10. What quality gets you into trouble?

 A. My clumsiness

 B. My sarcasm

 C. My introversion

 D. My inexperience

 E. My compassion

 F. My nosiness

Score Guide

1. A=0, B=5 **2.** A=2, B=5, C=6, D=3, E=1, F=4 **3.** A=6, B=1, C=2, D=4, E=3, F=5

4. A=1, B=2, C=3, D=4, E=6, F=5 **5.** A=5, B=2, C=1, D=6, E=3, F=4 **6.** A=3, B=5, C=2, D=6, E=1, F=4

7. A=6, B=5, C=4, D=2, E=1, F=3 **8.** A=3, B=6, C=2, D=1, E=4, F= 5 **9.** A=2, B=4, C=5, D=1, E=6, F=3

10. A=1, B=2, C=3, D=5, E=6, F=4

Your Total Score _____

Results

10-17 Inspector Jacques Clouseau

You are the accident prone, absent-minded inspector who always bumbles his way into winning the day. Even without much in the way of detective skills or co-ordination, you are incredibly lucky with your own distinct charm.

18-26 Philip Marlowe

You are the tall, dark and handsome private eye. Tough and always ready with a wise crack and a coffee, you are not above pushing boundaries to reach your goal, including using whiskey to loosen your mind or someone else's tongue.

27-35 Hercule Poirot

You are sharp and astute. When you're on the job, you're not looking to make friends. You keep your appearance as neat and orderly as your mind. Your probing questions may seem random, but the answers hold the key to solving the mystery.

36-43 Miss Marple

You hide your shrewd mind behind an unassuming guise. What looks like gossip on the surface is actually a deliberate strategy to get at the truth. Because people trust you right away, they tell you things they may not have told someone else.

44-52 Nancy Drew

You may be a young, amateur sleuth, but your self-possession and independence take you far. You are driven by curiosity. Your loyal friends are devoted to you and step up to help you when you need it. You are well-liked and known for your balance of sweetness and strength.

53-60 Precious Ramotswe

You are not just a private detective—you're a capable business owner and community leader. Your self-taught skills and your innate empathy draw people to you. Your drive to solve mysteries comes from a deep concern for other people's problems.

Which Famous Literary Character Are You?

The books that speak to us most contain characters in which we see our-
selves. This quiz teases out which of the most well-known literary personalities
is the best fit for you.

1. Are you male or female?

 A. Female B. Male

2. What qualities do you look for in friends?

 A. Honor and chivalry D. A sense of adventure
 B. Trustworthiness E. An element of fun
 C. A genuine nature F. Intelligence

3. What is your greatest fear?

 A. Being betrayed by a loved one D. Fear is an illusion of the mind
 B. Never finding true love E. An interrupted musical number
 C. A loved one in danger F. Losing a sibling

4. What is your dream job?

 A. A novelist D. A wife and mother
 B. A detective E. A nanny
 C. A knight F. Lord of an estate

5. What is your biggest flaw?

 A. My ego D. My sensitivity
 B. My temper E. My stark honesty
 C. I am practically perfect in every F. My flights of fancy
 way.

6. You are betrayed by a friend. How do you react?
 A. Challenge him to a duel
 B. Write a strongly-worded letter
 C. Get to the bottom of what happened and why
 D. Never speak to or of him again
 E. Yell and curse at him or her
 F. Give a proper scolding and move on

7. What do you carry with you at all times?
 A. An embroidered handkerchief
 B. A sword
 C. My formidable brain
 D. A book
 E. Everything I may need at a moment's notice
 F. My pride

8. What do your friends think of you?
 A. I am organized and capable
 B. I am sweet and charming
 C. I'm a bit of a tomboy
 D. I'm a little bit crazy
 E. I'm irritatingly observant
 F. I am hard to get to know but worth knowing

9. What is your guilty pleasure?
 A. Smoking a pipe
 B. Wearing pants instead of a skirt
 C. Tilting at windmills
 D. A spoonful of sugar
 E. Attending dances and social events
 F. Secretly solving other people's problems

10. What is your view on marriage?
 A. I want to marry for love
 B. I will marry if I find someone I trust absolutely
 C. I am a lifelong bachelor
 D. I yearn for a love from my dreams
 E. I keep my personal and romantic life to myself
 F. I am conflicted about it

Score Guide

1. A=0, B=5 **2.** A=4, B=6, C=2, D=3, E=1, F=5 **3.** A=6, B=2, C=4, D=5, E=1, F=3

4. A=3, B=5, C=4, D=2, E=1, F=6 **5.** A=4, B=3, C=1, D=2, E=5, F=4 **6.** A=4, B=2, C=5, D=6, E=3, F=1

7. A=2, B=4, C=5, D=3, E=1, F=6 **8.** A=1, B=2, C=3, D=4, E=5, F=6 **9.** A=5, B=3, C=4, D=1, E=2, F=6

10. A=2, B=6, C=5, D=4, E=1, F=3

Your Total Score _____

Results

10-17 Mary Poppins

You put the fun in functional. You are organized, capable and not to be trifled with, but you know how to let loose and have a good time. You're that person who has in her purse everything one could possibly need. There may actually be a Tiffany lamp in there.

18-26 Elizabeth Bennett

You're delightful, intelligent and well-loved in your community. You may be endearing and admirable, but you don't let anyone walk all over you. You put the "fem" in feminist, and you don't need a man to be happy, but you're also open to love if it's true.

27-35 Jo March

You're adventurous and playful, and though you can be clumsy at times, that only adds to your charm. You love to read and be outdoors. Passionate and fierce, you are devoted to your family and would do anything for them, though you sometimes lose your temper. If you put your foot in your mouth at times, it's only because you care so much you get away from yourself.

36-43 Don Quixote

You are an idealist and a romantic. You are chivalrous, self-sacrificing and full of good intentions, though you may go a bit overboard at times for a worthy cause or a person in need. A true gentleman, your friends are loyal to you, though at times they may think you're slightly nutty.

44-52 Sherlock Holmes

You are intelligent and observant, and somewhat eccentric. Obviously, you are always right. This makes you hard to be around at times, but friends and loved ones who get you and are willing to put up with your abrasiveness are solid gold. Your dizzying intellect is balanced out by a liberal, accepting nature and your ability to let loose and have a good time.

44-52 Fitzwilliam Darcy

You are aloof and arrogant, but in an endearing sort of way. You have been hurt in the past, so you are slow to show your feelings. You can come across coarse at first, but once your trust is earned, you are all in to the end. People who know you well find you dashing and have secret crushes on you. You don't like big parties and new people and prefer more intimate gatherings with close friends.

Which Famous Literary Character Are You?

Have you ever noticed how the names of dinosaurs, anatomical words and made-up science fiction terms sound alike? Dinosaurs, sci-fi and anatomy are three of the top avenues for kids with a scientific bent to channel their interests. Also, the words sound funny. Let's play!

1. An alethiometer is...
 A. A dinosaur
 B. A body part
 C. A reference from science fiction

2. A glabella is
 A. A body part
 B. A dinosaur
 C. A reference from science fiction

3. Which of the following is a kind of dinosaur?
 A. Ansible
 B. Diplodocus
 C. Cryostasis

4. What do ships in Star Trek use to power their warp engines?
 A. Dilithium
 B. Gnathion
 C. Gallimimus

5. Which of the following is another word for a knuckle?
 A. Aardonyx
 B. Terraform
 C. Condyle

6. Which of the following is a sci-fi villain with tentacles?
 A. Axilla
 B. Cthulhu
 C. Guanlong

7. A microraptor is...
 A. A tiny bone in the fifth toe
 B. A small, feathered dinosaur
 C. A pest that plagues the Millennium Falcon

8. The Hainish Cycle is...
 A. A series by Ursula K. Le Guin
 B. A phase involved in the extinction of dinosaurs
 C. A reaction in the brain that is triggered by strobe lights

9. A xiphoid process is...
 A. A strategy in an H.P. Lovecraft novel
 B. A piece of the sternum
 C. A process of evolution by which dinosaurs began
 to dwell on land

10. Which of the following would a Tyrannosaurus Rex eat?
 A. Canthus
 B. Yautja
 C. Hadrosaur

Results

0-15 **Good thing it's just for fun.**

Ok, we admit, this one pulls from a very specific set of knowledge bases. Hopefully you had fun saying some funny-sounding words.

20-35 **Jack of all trades, master of none.**

You have puzzled it out and made a respectable showing. You are likely very knowledgeable in one of the three categories, or you're skilled at the art of the process of elimination. Either way, well done!

40-50 **All hail the master of the nerds!**

You sure know your weird words. It seems you are a well-rounded science enthusiast, or you are an extremely lucky guesser.

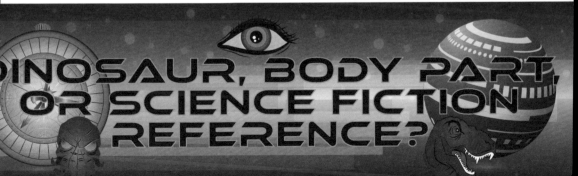

WHICH FAMOUS SCI-FI VILLAIN ARE YOU?

Sometimes, it's more fun to be the bad guy than it is to be the hero. If you were to embrace your dark side, which fantasy nemesis would you be?

1. Who would be your nemesis?

 A. Only a cosmic being of equal status is worthy
 B. Someone I underestimate
 C. Talking animals
 D. Someone I've wronged in the past
 E. Resilient rebels
 F. Someone who wronged me in the past

2. Who are your followers?

 A. People whose skills and dark natures match my own
 B. A doomsday cult
 C. Monsters of my own making, and nine very bad kings
 D. Strong creatures I can manipulate
 E. Power-hungry politicians
 F. Genetically-engineered super beings

3. How do you keep your minions in line?

 A. With my super-human intellect and strength.
 B. I strangle them with my mind.
 C. Simple: they worship me.
 D. By giving them rings of power, which I control. Mwa-ha-ha!
 E. By turning them into stone when they mess up.
 F. By kidnapping or torturing their loved ones.

4. What is your best feature?

 A. Overall superiority
 B. Tentacles. Oh, and wings!
 C. The all-seeing eye
 D. Eternal youth
 E. My horcruxes
 F. My commanding voice

5. What drives you?
 A. Adoration
 B. Revenge
 C. Power
 D. Ambition
 E. The Dark Side
 F. World domination

6. Why not use your powers for good?
 A. Tried that. Didn't work.
 B. Because mortals ruin everything.
 C. And help muggles? No thanks.
 D. Being good is for unimaginative children.
 E. And share the power? Not me.
 F. I can't help it if my destiny is to end the world. I am who I am.

7. What is your downfall?
 A. Pride
 B. My children
 C. I have vengeance tunnel vision
 D. Again, my horcruxes
 E. I do my best work from afar using my mind
 F. Determined halflings

8. If you could learn one lesson, what would it be?
 A. How to make less complicated plans
 B. How to stay with the person you love
 C. How to let your minions do the work for you
 D. How to tame a lion
 E. How to make and keep friends
 F. How to hang onto your jewelry

9. What is your go-to item of clothing?
 A. I don't wear clothes.
 B. A ring
 C. A white fur coat
 D. Dark robes
 E. A life-support system with a cape
 F. A sweater that shows off my physique

10. If you could be a normal human, what would you do?
 A. Read books about myself
 B. Spend more time with friends and family
 C. Play with my kids
 D. Join the Army
 E. Become a famous model
 F. Normal? Human? Disgraceful.

Score Guide

1. A=1, B=2, C=3, D=4, E=5, F=6 **2.** A=4, B=1, C=2, D=3, E=5, F=6 **3.** A=6, B=5, C=1, D=2, E=3, F=4
4. A=6, B=1, C=2, D=3, E=4, F=5 **5.** A=1, B=6, C=4, D=3, E=5, F=2 **6.** A=5, B=6, C=4, D=3, E=2, F=
7. A=3, B=5, C=6, D=4, E=1, F=2 **8.** A=6, B=5, C=1, D=3, E=4, F=2 **9.** A=1, B=2, C=3, D=4, E=5, F=
10. A=1, B=6, C=5, D=2, E=3, F=4

Your Total Score _____

Results

10-18 Cthulhu

You are the cosmic, tentacle-headed entity of H.P. Lovecraft's invention. You love to be worshipped by your cult followers, and just looking at you will drive a human or lesser god insane.

19-26 Sauron

Your less well-known origins resemble those of a fallen angel, but for Lord of the Rings fans, you the darkest of all powerful, evil beings. You don't even need to possess a body to spread your influence.

27-34 The White Witch

The White Witch of Narnia is a half-giant, half-genie who takes over the land of Narnia and enlists a network of spies to keep her subjects in line. You thrive on being feared!

35-42　Voldemort

Once the unassuming Tom Riddle, Voldemort was one of the most powerful wizards of his age, but chose evil after a rejection-filled adolescence. You hate muggles and strive to be the supreme ruler of the wizarding world.

43-51　Darth Vader

You are the infamous Jedi knight turned Sith Lord. You can kill with a thought, or light saber if necessary. You commune with the dark side of the force and have the most recognizable outfit in the galaxy.

52-60　Khan Noonien Singh

Revenge driven and possessing superior strength and insight, Khan is the famous villain of two generations of Star Trek fans. Your name is screamed in fury!

WHICH FAMOUS SCI-FI VILLAIN ARE YOU?

Which PRESIDENT are you?

Every president brings a unique approach to the most complicated and difficult job in the world. Based on your principles and priorities, which one do you most resemble?

1. Which quote inspires you the most?

 A. "Change will not come if we wait for some other person or some other time. We are the ones we've been waiting for. We are the change that we seek."

 B. "If the freedom of speech is taken away then dumb and silent we may be led, like sheep to the slaughter."

 C. "Nearly all men can stand adversity, but if you want to test a man's character, give him power."

 D. "Far and away the best prize that life has to offer is the chance to work hard at work worth doing."

 E. "If we ever forget that we are One Nation Under God, then we will be a nation gone under."

 F. "I have never advocated war except as a means of peace."

2. What is the U.S.A.'s greatest quality?

 A. Its military might

 B. Its example to the rest of the world

 C. Its unique origins

 D. Its resiliency

 E. Its stunning natural spaces

 F. Its people

3. What is the president's most important job?

 A. Nominating Supreme Court judges

 B. Defending the Constitution

 C. Setting the tone for the country and globe

 D. Balancing business prosperity with conservation

 E. Defending the ideals we fought for

 F. Reducing taxes and government spending

4. Choose your favorite historical event:

 A. The collapse of the Soviet Union D. The Panama Canal is built

 B. The end of the Civil War E. The Secret Service is created

 C. The first Continental Congress F. The first black President

5. Choose an important government agency:

 A. The National Forest Service D. U.S. Department of the Treasury

 B. The Department of Justice E. The Department of Agriculture

 C. Equal Employment Opportunity Commission F. Drug Enforcement Administration

6. What is your favorite U.S. state?

 A. Hawaii D. Ohio

 B. Illinois E. New York

 C. California F. Virginia

7. What is America's role in world affairs?

 A. Establishing trade partnerships C. Spreading liberty and democracy

 B. Using our resources to protect our interests D. Working with other countries to maintain world peace

8. Which issue means the most to you?

 A. National security D. Law and order

 B. Environmental conservation E. Civil rights and equality

 C. The economy F. Religious freedom

9. What would you want to be remembered for?

 A. Being loved by my country D. Making the world a better place

 B. Defining statesmanship E. My strength and integrity

 C. Bringing the country together F. Protecting our national treasures

10. If your image could be preserved on only one thing, what would it be?

 A. The side of a mountain D. A poster

 B. A coin E. A dollar bill

 C. A statue F. A war memorial

Score Guide

1. A=3, B=1, C=2, D=4, E=6, F=5 **2.** A=5, B=3, C=1, D=2, E=4, F=6 **3.** A=2, B=1, C=3, D=4, E=5, F=6
4. A=6, B=5, C=1, D=4, E=2, F=3 **5.** A=4, B=5, C=3, D=1, E=2, F=6 **6.** A=3, B=2, C=6, D=5, E=4, F=1
7. A=1, B=6, C=4, D=3 **8.** A=5, B=4, C=1, D=2, E=3, F=6 **9.** A=6, B=1, C=2, D=3, E=5, F=4
10. A=4, B=2, C=3, D=6, E=1, F=6

Your Total Score _____

Results

10-18 George Washington

Our first president invented the term, "Mr. President" and developed the tradition of the inaugural address. Oh, and he also oversaw the creation of our national government. He had no party affiliation and was against partisanship and for 'civic virtue'. His signing of the Jay Treaty avoided war with Britain and established peace and profitable trade for a decade.

19-26 Abraham Lincoln

Lincoln began his career as a lawyer before entering a life of politics. He saw the country through the Civil War and Reconstruction, preserving the union and paving the way for the abolition of slavery. Lincoln is known for redefining the Republican Party, and of course for his assassination five days after Robert E. Lee surrendered. In surveys of U.S. history scholars, Lincoln is ranked one a favorite of all U.S. presidents.

27-34 Barack Obama

Obama was the first black president. While he faced deep divides in the country, he inspired many and is known as a dynamic public speaker. Obama oversaw long-lasting and influential domestic changes, like marriage equality and the Affordable Care Act, and made international change as well when he signed the Paris Climate Agreement and pulled the U.S. out of combat in Iraq and Afghanistan.

35-42 Theodore Roosevelt

Teddy Roosevelt was a progressive Republican known for his love of nature and exploration. He was a hero of the National Parks system and championed the building of the Panama Canal. His "Square Deal" economic policy regulated rail roads and the purity of food and drugs to be fair to both businesses and consumers. He also won a Nobel Peace Prize for brokering an end to the Russo-Japanese War.

43-51 Ulysses S. Grant

Grant is the first president that comes to mind when you think of military presidents. A prominent Army general, Grant inherited a difficult job leading a country so recently divided by Civil War. Grant created the Department of Justice, and though he was a lifelong soldier, Grant's foreign policy sought to maintain peace. While he wasn't popular amongst politicians in his time and historians don't rank him with the best presidents, Grant led the effort to remove the traces of Confederate nationalism and slavery and protect African-American citizenship and civil rights.

52-60 Ronald Reagan

Reagan won his presidency with the largest ever Electoral College victory and enjoyed some of the highest approval ratings. Reagan began his career as an actor, and his magnetic charm helped him greatly in politics. His "Reaganomics" fiscal policies involved tax rate reduction to spur economic growth, economic deregulation, and reduction in government spending. While he broke a one-term streak by being the first president since Eisenhower to win re-election, in his first term he survived an assassination attempt and spurred what we still call the "War on Drugs".

Which PRESIDENT are you?

WHAT COMIC BOOK CHARACTER WOULD YOU BE?

SUPERHUM.

If you were blasted with gamma rays or bitten by a radioactive spider, what superhuman abilities would emerge? And would you use those abilities for good... or evil?

1. What were you like in school?

 A. I was an athlete.

 B. I hung out with my friends a lot.

 C. I did a lot of science experiments.

 D. I learned anything and everything I could.

 E. People liked me okay but I was mostly a loner.

2. How would you describe yourself as a friend?

 A. My friends always come to me for counsel. I know all my friends' secrets.

 B. My friends can always count on me to back them up in a fight.

 C. I only keep useful people around me.

 D. I am very busy and don't see my friends often, but they know that I'll always be there when they need me.

 E. My best friends are all plants and animals, so they don't say much.

3. Which of these attributes are you most proud of?

 A. My physique.

 B. My cunning.

 C. My intellect.

 D. My empathy.

 E. My compassion.

4. Which of these would be a dream job?

 A. Working from home as a freelancer

 B. Professional Athlete

 C. Psychologist

 D. Veterinarian

 E. Ruler of the world

5. Which of these activities appeals to you most?

 A. Creating things (ex: sewing, crafting, woodworking)
 B. Gardening
 C. Staying in shape
 D. Spend time with friends
 E. Taking selfies

6. Which of these would be a room in your dream home?

 A. A tranquil spa
 B. A green house
 C. A personal gym
 D. A private study
 E. A vault filled with artifacts and price-less treasures

7. Which of these is most important when facing a fight?

 A. Staying two steps ahead of your opponent
 B. Brute strength
 C. De-escalating the situation
 D. Winning
 E. Protecting innocent bystanders

8. Which of these is most important to you in a romantic partner?

 A. Obedience
 B. Mystery
 C. Ambition
 D. Loyalty
 E. Kindness

9. A building is about to topple. What do you do?

 A. Save the puppy from certain doom
 B. Laugh
 C. Push it back up again with my massive arms
 D. Rescue as many people as I can before it falls
 E. Use my mind to suspend it in midair as long as possible

10. Which of these is your favorite comic book icon?

 A. Superman
 B. Professor X
 C. Batman
 D. Aquaman
 E. The Joker

Score Guide

1. A=1, B=2, C=3, D=5, E=4
2. A=2, B=1, C=5, D=4, E=3
3. A=1, B=4, C=5, D=2, E=3
4. A=4, B=1, C=2, D=3, E=5
5. A=4, B=3, C=1, D=2, E=5
6. A=2, B=3, C=1, D=4, E=5
7. A=2, B=1, C=3, D=5 E=4
8. A=5, B=4, C=1, D=4, E=2
9. A=3, B=5, C=1, D=4 E=2
10. A=1, B=2, C=4, D=3, E=5

Your Total Score _____

Results

10-17 The Super Human

You are complete with super strength, speed, and a heightened healing ability. Your drive, ambition and sheer power would make you a great leader of any super hero team. You would be the heaviest hitter, and the first person the world would turn to when facing a galactic threat. It is a lot of weight to carry, but you have the strength to do it.

19-25 The Telepath

Your fascination with the human mind and communications skills would make you mental giant of your super hero crew. Your teammates would consider you a great confidant and trust you with their secrets and fears. Your mind reading abilities can help to avoid conflict, but when the big guns are needed, you don't have a problem hurling boulders with your telekinesis or controlling someone's mind.

26-33 The Environmental Crusader

You draw your strength from the Earth's plants and animals, and they answer to your command. Imagine borrowing the strength of an elephant at a whim or controlling vines to ensnare evil-doers. You would serve as the moral compass to any super hero team. You are able to see things objectively while still having compassion.

34-41 The Masked Vigilante

You work alone. Your cunning, training, and the occasional gadget are all you need to fight crime. Most of your loved ones, as well as your super hero brethren, do not know your true identity and you'd like to keep it that way. You team up when the job calls for it, but you'd rather not have other heroes getting in your way.

42-50 The Villain

Every good comic book needs an arch-nemesis and you play the part beautifully. You are power hungry and bent on world domination, and perhaps even form your own league of villains.

HOW OLD IS YOUR INNER CHILD?

Adulting is hard, that's why we all have a kid inside waiting to be indulged when we need a break. When your inner child emerges, exactly how 'young at heart' are you?

1. You take a child in your life to the toy store. Do you:
 A. Squeeze all the stuffed animals as you walk past
 B. Walk out wearing a pirate hat or tiara with a bag of goodies of your own in hand
 C. Sip your pre-purchased coffee while the kid browses
 D. Know all the characters on the games and movies

2. It's your turn to plan a birthday celebration at work. Do you:
 A. Order balloons, streamers, party hats and kazoos
 B. Choose a fun theme
 C. Think up party games that will make everyone laugh
 D. Select a color scheme and make a playlist

3. Something sad happens in your life. Do you:
 A. Have a good cry in your pajamas with a parent on the phone
 B. Lean on friends for support
 C. Cry in private and try to cheer yourself up
 D. Confide in a small, trusted group

4. When you're at the beach, do you:
 A. Read or talk to friends on a towel or chair
 B. Build sand castles
 C. Play Frisbee, play catch or body surf
 D. Go for walks and find shells

5. Choose a Christmas movie to watch:
 A. Elf
 B. Charlie Brown Christmas
 C. Home Alone
 D. Die Hard

6. Where would you shop for a gift for your best friend?
 A. The Sharper Image
 B. Mod Sock
 C. Uncommon Goods
 D. The Disney Store

7. You come into extra money. Do you:
 A. Buy a gadget or new phone you've been eyeing
 B. Treat your friends to a fun night out or group trip
 C. Go shopping at your favorite store
 D. Buy a pinball machine

8. Someone does something that offends you or makes you mad. Do you:
 A. Tell an authority figure
 B. Confront them about it
 C. Vent to your friends
 D. Bottle it up and avoid that person

9. Someone throws you a surprise party. Do you:
 A. Find out and make sure you look your best
 B. Woo hoo! Cake and presents!
 C. Tear up a little
 D. Thank everyone and enjoy

10. The nieces and nephews (or equivalents) in your life think you're:
 A. Super fun
 B. Kind of embarrassing
 C. Cool
 D. Aloof and worldly

Score Guide

1. A=1, B=2, C=3, D=4, E=5, F=6 **2.** A=4, B=1, C=2, D=3, E=5, F=6 **3.** A=6, B=5, C=1, D=2, E=3, F=4
4. A=6, B=1, C=2, D=3, E=4, F=5 **5.** A=1, B=6, C=4, D=3, E=5, F=2 **6.** A=5, B=6, C=4, D=3, E=2, F=1
7. A=3, B=5, C=6, D=4, E=1, F=2 **8.** A=6, B=5, C=1, D=3, E=4, F=2 **9.** A=1, B=2, C=3, D=4, E=5, F=6
10. A=1, B=6, C=5, D=2, E=3, F=4

Your Total Score _____

Results

10-17 True kid at heart

You may look like a fully grown human, but in your head, you're between the ages of 5 and 8. In a charming way. Adulthood hasn't affected your ability to find magic in the everyday. You are imaginative and trusting, and you find fun easily. When you feel stressed, it doesn't last long. You have kept your favorite stuffed animals, keep them out where they can be seen, and even hug them now and then.

18-25 Pre-adolescent on the inside

Your inner child is between the ages of 9 and 11. You don't hesitate to play and show your inner child around other adults without shame, but your games of choice are more of the bike riding, roller blading, or video game playing variety. With some time to reflect and plan, you let go of stress and worry without too much strife. You still have your favorite toys or childhood stuffed animals, but they're stowed away where guests can't see them.

26-32 Adolescent brain

Underneath that adult exterior is a tween waiting to come out. You love current popular music and know the slang the young folks are using. When you're with old friends, you revert back to your middle school self without missing a beat. You sometimes feel the call of a younger inner child but you're too embarrassed to let it show, except when you're with your closest friends and family.

33-40 Beware the teenager

Your inner child is too cool for school. So cool, in fáct, that it doesn't really feel like an inner child at all, but rest assured: it is. When someone younger-at-heart than you suggests an arcade or amusement park, you're the one who rolls their eyes, though you are secretly totally excited on the inside. Like an all-knowing teen, you approach stress with confidence. You may seem all "whatever", but you still need back-up and reassurance from your squad.

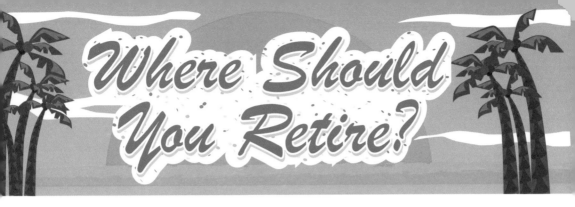

Where Should You Retire?

You've worked hard and struck it rich and you're ready for retirement, but where? There are so many beautiful places, how can you choose where to spend a life of leisure?

1. What is your favorite type of climate?
 A. I love to experience all four seasons
 B. Tropical
 C. Cold and snowy
 D. Warm and dry
 E. Not too warm and not too cold

2. How would you like to relax during retirement?
 A. Shopping
 B. Lying on the beach
 C. Fishing
 D. Hiking
 E. Sailing

3. What type of food do you like best?
 A. Pastries, chocolate and wine
 B. Fresh fruits
 C. Fresh seafood
 D. Spicy
 E. Mediterranean

4. What type of scenery relaxes you?
 A. Classic architecture, city scenes and art
 B. Oceans, beaches and dolphins
 C. Mountains, lakes and whales
 D. Cactus, sandy desert and starry skies
 E. Rugged cliffs, beautiful landscapes and villages

5. Which of these activities would you rather be doing?
 A. Painting
 B. Surfing
 C. Riding 4-wheelers
 D. Camping
 E. Riding a Vespa

6. What type of live entertainment would you like to see?
 A. A stage play in a theatre
 B. Dancing and drumming around a fire
 C. Live band and rock show
 D. Native American folk dancing
 E. Wine touring and tasting

7. What type of house do you want to retire in?
 A. Lovely condo with a view
 B. Beachfront bungalow or home
 C. A cabin in the woods
 D. Pueblo style home
 E. Village cottage

8. Pick an animal that you enjoy seeing.
 A. Cats and pigeons
 B. Seals and seagulls
 C. Bears and moose
 D. Wolves and road runners
 E. I don't care for animals

9. What landmark do you like most?
 A. Eiffel Tower
 B. Diamond Head Mountain
 C. Glaciers
 D. Grand Canyon
 E. Castles and temples

10. What type of social atmosphere do you want to retire in?
 A. Busy and social with lots of things to see and do
 B. Very laid back and easy going tempo
 C. I want serenity, peace and quiet with no noise
 D. Calming and meditative surroundings
 E. Neighborly countryside but not too crowded

Score Guide

1. A=1, B=2, C=3, D=4, E=5
2. A=1, B=2, C=3, D=4, E=5
3. A=1, B=2, C=3, D=4, E=5
4. A=1, B=2, C=3, D=4, E=5
5. A=1, B=2, C=3, D=4, E=5
6. A=1, B=2, C=3, D=4, E=5
7. A=1, B=2, C=3, D=4, E=5
8. A=1, B=2, C=3, D=4, E=5
9. A=1, B=2, C=3, D=4, E=5
10. A=1, B=2, C=3, D=4, E=5

Your Total Score _____

Results

10-17 Paris

You are French at heart. Art, nightlife and infusion of culture appeals to your curious nature. You love the markets, shopping and wine. You want to feel like you're on vacation 24/7, and Paris is rich in history and activities. You want to stay inspired in your retirement.

19-25 Hawaii

You belong on a tropical island. You want to adopt the easy going lifestyle and enjoy the laid back pace. The adventurer inside of you loves being close to the beach and surf. You want to rub elbows on the big island of Oahu and live in a beachfront home.

26-33 Alaska

You are looking for an earthier lifestyle. You want to be far away from the noise and hustle of the city, to be one with nature and enjoy its beauty. Quiet activities like fishing and canoeing are what you most look forward to. You love mountains and landscapes as your daily view.

34-41 New Mexico

You belong out west. The scenic dry climate in the desert appeals to your spiritual side. You want to delve in to the culture and history of the natives and meditate. You also love the perfect blend of rugged terrain with a village feel. The desert offers a special healing energy that further enhances your retirement.

42-50 Santorini

Greece has everything you need. You love the air and seascape village countryside of this mini paradise. You are drawn to the simple lifestyle and sense of community. You love the energy from the sun on this side of the planet. You want to live a life you've never seen and spend time sailing and relaxing. You want to adopt the self-sufficient attitude of the city.

Where Should You Retire?

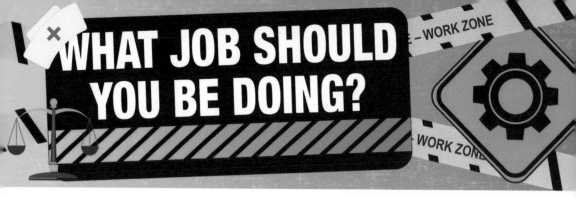

WHAT JOB SHOULD YOU BE DOING?

Do you sit at a desk wondering "what if", or are you already in the perfect job for you?

1. What is the purpose of a job?
 A. To pay bills
 B. To earn money and benefits
 C. To make a difference in the world
 D. To fulfill dreams
 E. To gain accomplishments

2. Would you rather:
 A. Manage your own time
 B. Have a great life outside of work
 C. Represent your own brand
 D. Contribute to society
 E. Be proud of your profession

3. How much school do you need?
 A. I like to be self-taught
 B. School of life, baby
 C. High school, yes. College, maybe.
 D. If you want a high-paying job, school is an investment
 E. A college degree is a must

4. What do you do with your time off?
 A. Relax and unwind
 B. Travel
 C. It's all about the stay-cation
 D. Time off? What is this "off"?
 E. Do my best to unplug

5. Choose a section of the newspaper:
 A. Business
 B. Politics
 C. Health and education
 D. Arts and leisure
 E. Editorials

6. Would you rather:
 A. Work alone
 B. Work as a team
 C. Play your role

 D. Be the boss
 E. Brainstorm alone, then work with a team

7. Choose a buzzword:
 A. Disrupt
 B. Millennial
 C. Influencer

 D. Self-care
 E. Workflow

8. You're at a party. Which group would you rather join?
 A. A cluster of people checking their phones
 B. A group that is laughing a lot
 C. The small group in the kitchen

 D. An interesting individual you've never met
 E. A small group in deep conversation

9. Are you:
 A. Detail-oriented
 B. Self-driven
 C. Personable

 D. Idea-driven
 E. Ambitious

10. When you were a kid, you got in trouble for:
 A. Lack of attention span
 B. Arguing
 C. Not joining clubs or extra activities

 D. Getting clothes dirty
 E. Talking in class

Score Guide

1. A=1, B=2, C=5, D=3, E=4 **2.** A= , B=2, C=3, D=4, E=5 **3.** A=1, B=2, C=3, D=4, E=5
4. A=5, B=4, C=2, D=3, E=1 **5.** A=3, B=4, C=5, D=2, E=1 **6.** A=1, B=2, C=5, D=4, E=3
7. A=3, B=2, C=1, D=5, E=4 **8.** A=1, B=5, C=2, D=3, E=4 **9.** A=5, B=1, C=2, D=3, E=4
10. A=3, B=4, C=1, D=5, E=2

Your Total Score _____

Results

10-18 Freelancer

You like not having a boss, but you don't want to be someone else's boss, either. You also like the flexibility of working from home. Working as a writer, designer, social media marketer or consultant gives you the autonomy you crave, and you're willing to live within modest means for the freedom of that lifestyle.

19-26 Barista

You like hustle and bustle without too much responsibility. People like you and you like them, but you don't need to invest in a deeper interaction in the workplace. Being around people with noise and energy around you is fun, but you mostly like to earn a steady wage and get your real fulfillment outside of work.

27-34 Entrepreneur

You are an idea person. You see ways to make existing things better, or think up something new to fulfill a demand. You don't like to do the same thing for too long, so coming up with a new business venture, making a pitch and getting supporters excited about it gives you life. You can stick with it as long as you want, then change lanes, either selling or stepping into a figurehead role when the next big idea strikes.

35-42 Lawyer

You're smart and put your own spin on old-fashioned. You like to help people and pursue justice in the system, but you also want to be able to drive a nice car, own a home, and build a reputation. Lawyers also have a lot of possibility to branch out into different fields, like education, politics, and the corporate world.

43-50 Nurse

Nurses are in the most trusted occupation in the country. You are a hard worker, a healer, and are patient, reliable, and calm. Not much phases a nurse. While you want to earn a livable wage in a field that never struggles to find work, you also care about helping people and like to use your brain and improve your skills.

What TV character would you be friends with?

TV shows bring people we love to love (and love to hate) into our homes. You know you wonder what it would be like to hang out with some of them, so let's find out which on-screen character would be your best bud.

1. What do you like to do with your friends?
 A. Play video games
 B. Watch sports
 C. Eat French fries and talk
 D. Watch your favorite old TV shows
 E. Hang out at a coffee shop
 F. Fight vampires

2. What quality do you appreciate in a friend?
 A. Trustworthiness
 B. Intelligence
 C. Humor
 D. Loyalty
 E. Open-mindedness
 F. Listening skills

3. When you're about to say or do something you'll regret, how should a friend respond?
 A. Mock you until you see the error of your ways
 B. Watch you do it and then make fun of you after
 C. Warn you of the possible consequences
 D. Write a song about it
 E. With sarcasm
 F. Eat a sandwich

4. What do you want a friend to bring you when you are sad?
 A. Two pizzas
 B. Your guitar
 C. A hug and a snarky comment
 D. A fascinating anecdote
 E. A comic book and a plot for revenge
 F. A spell to help you feel better

5. How do you stand up for your friends?

A. With my ninja skills

B. Sorry, they have to fend for themselves

C. With logic

D. By offering to kick their enemy's butt

E. By encouraging them to stand up for themselves. And if that doesn't work, mugging isn't off the table.

F. By cracking jokes that belittle the enemy.

6. What is the best thing about friendship?

A. Having a partner in crime

B. Making each other stronger

C. Lightening each other up

D. Accepting each other for who they are

E. Having a sounding board for your thoughts and feelings

F. Having someone to hang out with

7. What is the deal breaker that would make you cut a friend off?

A. Making me think too much

B. Recklessness

C. Eating food off my plate

D. Lying to me

E. Wanting me to be more "normal"

F. Break one of my many neurotic rules

8. What is the most difficult thing that can test a friendship?

A. Living near a hell mouth

B. Choosing between the needs of the many and the needs of the few (or the one)

C. Laying a finger on your Butter-finger

D. Wanting to date the same person

E. Setting you up with a horrible person

F. Moving to Minsk

9. What movie would you want to reenact with your friends if you could?

A. Caddyshack

B. Star Wars

C. Die Hard

D. Bridget Jones' Diary

E. Hair

F. Alien

10. If you were to go on a trip with your friends, where would you want to go?

A. To the international space station

B. Sunnydale, CA

C. On a fun, never-ending cruise

D. Woodstock

E. New York City

F. London, baby!

Score Guide

1. A=2, B=3, C=4, D=1, E=5, F=6 **2.** A=6, B=1, C=2, D=3, E=5, F=4 **3.** A=4, B=2, C=1, D=5, E=6, F=3

4. A=3, B=5, C=4, D=1, E=2, F=6 **5.** A=6, B=2, C=1, D=3, E=5, F=4 **6.** A=2, B=6, C=1, D=5, E=4, F=3

7. A=2, B=1, C=3, D=6, E=5, F=4 **8.** A=6, B=1, C=2, D=3, E=4, F=5 **9.** A=2, B=1, C=3, D=4, E=5, F=6

10. A=1, B=6, C=2, D=5, E=4, F=3

Your Total Score _____

Results

10-18 Spock

Live long, and prosper! Spock made it cool to be nerdy. His reliance on logic, his propensity to find odd things fascinating, and his dry, unintentional humor made him an icon that spanned generations of TV viewers and Star Trek fans.

19-27 Bart Simpson

Don't have a cow, man. Everyone needs a little mischief in their lives, and Bart certainly brings it. He may have been in elementary school for a long time, but he is smarter than he lets on and his accomplishments include discovering a comet and winning an award for his website.

28-36 Joey Tribbiani

How you doin'? What Joey lacks in smarts, he makes up for in fun and loyalty. He is a lovable loser, but when you need him he'll be there for you. He loves the New York Knicks, sandwiches, girls, cardboard box forts, and bubble wrap.

37-44 Elaine Benes

Elaine is smart, assertive, funny and just as comfortable with a group of women as she is with a group of men. She is an adorable neurotic and doesn't miss an opportunity to give her friends a ribbing when they do or say something worth mocking.

45-52 Phoebe Buffay

Phoebe didn't finish high school, but is fluent in French. What she lacks in book smarts she makes up for with street smarts and a healthy dose of eccentricity. She has a pure heart, a strong moral core, interesting taste in music, and the craziest stories you'll ever year.

53-60 Buffy Summers

Before Daenerys Targaryen entered the screen, strong women of all ages identified with Buffy. Buffy is a mean girl turned vampire slayer. She didn't ask for her skills, but her strength, agility, intuition, healing, and gang of misfit friends save the world from demons time and again.

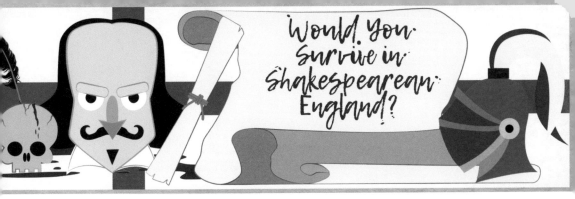

Would You Survive in Shakespearean England?

Anglophiles beware: the average life expectancy in Elizabethan England was only 42. If you were plopped into the 1500s, how would you do?

1. Thou hast a boo boo. How do you treat it?
 A. Bleed out the bad humours
 B. Get thee to a river and apply leeches
 C. Visit the local "wise woman"
 D. Disinfectant and a Band-Aid

2. Which animal should you avoid at all cost?
 A. Bears
 B. Rats
 C. Birds
 D. Spiders

3. Thou hast a toothache. What do you do?
 A. Pull the tooth out. (Sorry, anesthetics haven't been invented yet.)
 B. Bleed out the bad humours
 C. Visit the dentist
 D. Ignore it until it falls out by itself.

4. Where should children spend their days?
 A. With their nannies
 B. At school
 C. Working with their families
 D. Running about in the streets

5. You feel like having some fun. What should you do?
 A. Go bear baiting
 B. Go to the movies
 C. See a play at the Globe
 D. Invite a popular musician to come play for you

6. What is the most important element to a healthy society?
 - A. Sanitation
 - B. Medicine
 - C. Noble lineage
 - D. Education

7. Which industry should you join?
 - A. Technology
 - B. Textiles
 - C. Agriculture
 - D. Food service

8. Who is in charge of helping those in need?
 - A. The parish
 - B. Parliament
 - C. Property owners
 - D. Hospitals

9. Would you rather wear:
 - A. Furs, jewels and embroidered cloth
 - B. Jeans and a t-shirt
 - C. Purple
 - D. Sturdy boots, a vest/bodice, and a hat

10. What would you like for dinner?
 - A. Salted beef with fruit and wine
 - B. Brown bread and eggs with beer
 - C. Pizza
 - D. Mutton with bread and ale

Score Guide

1. A=3, B=2, C=4, D=1 **2.** A=2, B=4, C=3, D=1 **3.** A=4, B=3, C=1, D=2

4. A=2, B=1, C=4, D= 3 **5.** A=2, B=1, C=4, D=3 **6.** A=4, B=3, C=2, D=1

7. A=1, B=4, C=3, D=2 **8.** A=4, B=3, C=2, D=1 **9.** A=2, B=1, C=3, D=4

10. A=3, B=2, C=1, D=4

Your Total Score _____

Results

10-20 Thou wouldst surely perish

Disable the time machine and step out. Modern comforts and conveniences (and medicine) are a better bet for you. If you go, you'll likely catch the plague.

21-31 Thou shouldst marry money

Unless you end up a member of the privileged aristocracy, you probably wouldn't last into middle age, a.k.a. your 20s.

32-40 Thy scrappy ways wouldst serve you well

Well played! You would last to the ripe old age of 40. With your knowledge of how the people lived in the "golden age" of English history, you would manage swimmingly.

IF YOU WERE A CAR, WHAT WOULD YOU BE?

Cars are made to get us where we need to go, but their owners also tend to imbue them with personalities, voices, and even names. If you were a car, what would you be?

1. You're on a road trip. Would you rather:
 A. Avoid the highway for more windy roads
 B. Drive fast to get to your destination
 C. Ride in comfort
 D. Stop at all the interesting sights
 E. Avoid the highway for better scenery

2. Would you rather:
 A. Listen to NPR or podcasts
 B. Listen to country music
 C. Listen to the engine purr
 D. Listen to dance music
 E. Listen to classical or avant garde music

3. Would you rather:
 A. Use up gas for more power
 B. Use alternative fuels
 C. Carpool with friends
 D. Use less gas but still go fast
 E. Measure gas in litres

4. Would you rather:
 A. Speak in a British accent
 B. Speak several languages fluently
 C. Speak with good grammar
 D. Speak in a silly voice
 E. Speak plain English

5. Which dog would you rather have:
 A. A cavalier King Charles spaniel
 B. A big, friendly mutt
 C. A border collie
 D. A beagle
 E. A poodle

6. Would you prefer:
 A. Espresso
 B. Tea
 C. Regular coffee
 D. A latte or cappuccino
 E. Soda

7. Would you rather:
 A. Work from home
 B. Work at a bookstore or coffee shop
 C. Work as a manager
 D. Own the business and make my own hours
 E. Be rich and never work again

8. It's Saturday. Would you rather:
 A. Host a cookout or potluck
 B. Do something outdoors like a hike or bike ride
 C. Go shopping alone or with friends
 D. Do something you've never done before
 E. Play golf or tennis at a club

9. You're in your late 60s. Would you rather:
 A. Retire and travel the world
 B. Keep working as long as you can
 C. Live on your savvy tech investments
 D. Buy a beach house
 E. Work part time and move in with family

10. Time to buy clothes. Would you rather:
 A. Support green businesses
 B. Buy vintage or homemade
 C. Invest in quality items
 D. Get good deals on my favorite brands
 E. Wear jeans and t-shirts

Score Guide

1. A=4, B=3, C=5, D=2, E=1 **2.** A=1, B=3, C=5, D=2, E=4 **3.** A=3, B=1, C=2, D=4, E=5
4. A=5, B=4, C=1, D=2, E=3 **5.** A=5, B=3, C=1, D=2, E=4 **6.** A=4, B=5, C=3, D=1, E=2
7. A=1, B=2, C=3, D=4, E=5 **8.** A=3, B=1, C=4, D=2, E=5 **9.** A=4, B=3, C=1, D=5, E=2
10. A=1, B=2, C=5, D=4, E=3

Your Total Score _____

Results

10-17 Tesla

You embrace new technology and innovation. Gadgets are your friends, especially when they improve your lifestyle. You try to be green and eco-friendly as much as you can, and it's worth it to pay extra for organic food and recycled materials. You enjoy being around like-minded individuals and are liberal-minded.

18-25 VW Beetle

The Volkswagon Beetle—the original design, of course—was known for its charisma. You are cute and quirky. You live within your means, and you don't need trunk space or speed, as long as you're having an interesting experience. Your friends will pile into your car to spend time with you.

26-33 Mustang

The Mustang is classic Americana, vivacious and full of flare. It's a gas guzzler, but it's a fair trade for power and panache. You're not interested in being fancy, but you do like to have a good time with your friends at a bowling alley or cookout and enjoy the fun of driving.

34-41 Porsche 911

The Porsche is fast and chic. It exudes sleek European style, but it isn't the most expensive option out there and can actually be reasonably priced. You are sophisticated and love to look good and wear high-end name brands, but you're not above a good bargain. You enjoy the finer things in life, but you can also relax and have a good time doing whatever your friends want to do.

42-50 Jaguar

The Jag is pure, British luxury. It spares no expense for a quiet, smooth ride with leg room and beautiful details. Some may say it's snobby, but those people don't appreciate craftsmanship, elegance and historic design. You are or want to be a member of a social club or philanthropic organization.

IF YOU WERE A CAR, WHAT WOULD YOU BE?

WHAT KIND OF DINOSAUR WOULD YOU BE?

If you roamed the prehistoric fields and streams, which "terrible lizard" would you be?

1. Would you rather eat:
 A. Cheeseburgers
 B. Salad
 C. Fried Brussels sprouts
 D. Cordon bleu

2. You on the Fantastic Four! Would you rather be:
 A. Mr. Fantastic (super stretchy)
 B. The Thing (made of rocks)
 C. Invisible Woman
 D. Human Torch

3. Would you rather:
 A. Win a sword fight
 B. Win a pie eating contest
 C. Win a boxing match
 D. Win a bowling match

4. Which mythical creature would you rather be?
 A. A minotaur
 B. A sphinx
 C. A mermaid
 D. A dragon

5. Would you rather have:
 A. Longer arms
 B. A shorter neck
 C. More horns
 D. Wings

6. Which zoo animal would you rather be?

 A. Giraffe C. Lion

 B. Rhinoceros D. Cheetah

7. To get someone's attention, would you rather:

 A. Wait until they notice you C. Tap them on the shoulder

 B. Yell their name D. Sneak attack

8. Would you rather be:

 A. A Rottweiler C. A border collie

 B. A Great Dane D. A bull dog

9. Would you rather be:

 A. The bully C. A kid who stands up for him/her-self

 B. The hero D. The kid who is too big to be bothered

10. Would you rather:

 A. Play in the mud C. Play dodge ball

 B. Play laser tag D. Play horseshoes

Score Guide

1. A=1, B=4, C=3, D=2 **2.** A=4, B=3, C=2, D=1 **3.** A=2, B=4, C=1, D=3

4. A=3, B=2, C=4, D=1 **5.** A=1, B=4, C=3, D=2 **6.** A=4, B=3, C=1, D=2

7. A=4, B=1, C=3, D=2 **8.** A=1, B=4, C=2, D=3 **9.** A=4, B=2, C=1, D=3

10. A=1, B=2, C=3, D=4

Your Total Score _____

Results

10-17 Tyrannosaurus Rex

Strong and reliant on brute force, the T-rex is the biggest and the baddest dino on the food chain. Your arms may be short, but your roar is mighty.

18-25 Velociraptor

Cunning, fast velociraptor is an intelligent carnivore. It can out jump and out-think its prey and is a master of both strategy and surprise.

26-32 Triceratops

Triceratops may have been an herbivore, but it was not easy prey. It wasn't stealthy, but it had means to fight back with its horns and sharp beak.

33-40 Brontosaurus

One of the largest creatures ever to walk the earth, the gentle "Thunder lizard" was so big and heavy that it likely spent a lot of time in or near water.

WHAT FAMOUS ARTIST WOULD YOU BE?

There's an artist inside everyone, some of them just haven't found their style yet. Which famous painter would you be like if you decided to pick up the brush?

1. Would you rather:
 A. Take a selfie with something you find beautiful
 B. Take a photo and add a filter
 C. Blend a photo with another in an interesting way
 D. Draw on a photo to turn it into something else

2. You're at a museum or gallery. Would you rather:
 A. Enjoy the landscapes and portraits
 B. Find something new and weird
 C. Interpret the art for yourself
 D. Find something that moves you

3. You're at a paint bar with an artist guiding you through a painting. Would you rather:
 A. Add funny things to the painting
 B. Follow the steps to make the painting
 C. Follow the steps but change the colors
 D. Go rogue and paint whatever you feel like

4. Would you rather:
 A. Make a collage
 B. Melt a clock
 C. Color in an adult coloring book
 D. Read a poem

5. Art is about:
 A. Playing with colors and shapes
 B. Surprise and creativity
 D. Expressing emotion
 E. Capturing beauty

6. Would you rather read:
 A. People
 B. Time
 C. Vogue
 D. Rolling Stone

7. Would you rather:
 A. Join the circus
 B. Backpack across Europe
 C. Join a political rally or protest
 D. Hop a freight train and see where you end up

8. Would you rather:
 A. Be remembered for your mustache
 B. Be remembered as a bit crazy
 C. Be remembered for how you made people feel
 D. Be remembered for your talent

9. Would you rather:
 A. Lose your vision
 B. Lose your reputation
 C. Lose your ear
 D. Lose your memory

10. Would you rather:
 A. Play an instrument
 B. Write a symphony
 C. Sing
 D. Listen to music

Score Guide

1. A=1, B=2, C=3, D=4 **2.** A=1, B=3, C=4, D=2 **3.** A=3, B=1, C=2, D=4
4. A=4, B=3, C= 1, D=3 **5.** A=4, B=3, C=2, D=1 **6.** A=1, B=2, C=3, D=4
7. A=3, B=1, C=2, D=4 **8.** A=3, B=1, C=2, D=4 **9.** A=4, B=3, C=1, D=2
10. A=2, B=4, C=3, D=1

Your Total Score _____

Results

10-17 Vincent Van Gogh

You love to play with light and color, taking the real world and reinterpreting it in new ways. Self-portraits help you express and find yourself. You appreciate movement and whimsy, and if channeling your creativity makes you go a bit mad at times, so be it.

18-24 Pablo Picasso

You have a more somber approach and use art to express emotion. Color and shapes brings out the mood of a painting, not necessarily the realistic colors and shapes of the subject. You also like to use other media, like poetry, stage design and sculpture, to channel your artistic style.

25-32 Salvador Dali

You love the unexpected and outrageous, and you embrace excesses and oddities. You like to use symbols or metaphors, and art is more about exploring ideas than emotions. Imagination is your top priority. Everyday life bores you.

33-40 Wassily Kandinsky

For you, art is about improvisation. You prefer to use abstracts to give an impression instead of interpreting "real" objects or people. For you, art takes something intangible like a symphony or musical chord and turns it into a visual image.

Which historical figure would you be?

Once or twice a generation, someone comes along who changes or influences the country forever. Each one worked his or her way up from nothing to worldwide fame. Which one matches your personality the most?

1. Would you rather:
 A. Redefine the entertainment industry
 B. Redefine a country's foundation
 C. Redefine a literary movement
 D. Redefine beauty
 E. Redefine science
 F. Redefine freedom

2. Which quote would you rather hang on your wall?
 A. "Imperfection is beauty, madness is genius and it's better to be absolutely ridiculous than absolutely boring."
 B. "Times and conditions change so rapidly that we must keep our aim constantly focused on the future."
 C. "Hold fast to dreams, for if dreams die, life is a broken-winged bird that cannot fly."
 D. "One never notices what has been done; one can only see what remains to be done."
 E. "Each person must live their life as a model for others."
 F. "I never expect to see a perfect work from an imperfect man."

3. Would you rather:
 A. Be remembered for your creativity
 B. Be remembered for your courage
 C. Be remembered for your intelligence
 D. Be remembered for how you made people feel
 E. Be remembered for your words
 F. Be remembered for your discoveries

4. Would you rather:
 A. Read poetry
 B. Read a magazine
 C. Read a novel
 D. Read a history book
 E. Read a biography
 F. Read a science book

5. Would you rather:
 A. Be underestimated
 B. Be taken seriously
 C. Be synonymous with your industry
 D. Be remembered only for your successes
 E. Be free to do what you want
 F. Be a genius

6. Would you rather be involved in:
 A. Politics
 B. Scientific research
 C. Innovation
 D. Entertainment
 E. The civil rights movement
 F. The literary scene

7. Would you rather:
 A. Be appreciated after you're gone
 B. Win a Nobel Prize
 C. Live on through your work
 D. Live forever
 E. Stand up for what's right
 F. Win a famous battle

8. 100 years after you're gone, would you rather:
 A. Be brought back to life through cryogenics
 B. Have your face appear on money
 C. Know that your efforts made a difference
 D. Have your work read in schools
 E. Influence young people to be themselves
 F. Know that your work saved lives

9. Would you rather meet:
 A. Oprah
 B. Steve Jobs
 C. Reese Witherspoon
 D. Michael Jackson
 E. Bill Nye
 F. Barack Obama

10. Would you rather live in:
 A. Harlem
 B. Alabama
 C. Virginia
 D. Los Angeles
 E. Europe
 F. Orlando

Score Guide

1. A=1, B=6, C=3, D=2, E=4, F=5
2. A=2, B=1, C=3, D=4, E=5, F=6
3. A=1, B=5, C=6, D=2, E=3, F=4
4. A=3, B=2, C=1, D=6, E=5, F=4
5. A=2, B=5, C=1, D=6, E=3, F=4
6. A=6, B=4, C=1, D=2, E=5, F=3
7. A=2, B=4, C=3, D=1, E=5, F=6
8. A=1, B=6, C=5, D=3, E=2, F=4
9. A=5, B=1, C=2, D=3, E=5, F=6
10. A=3, B=5, C=6, D=2, E=4, F=1

Your Total Score _____

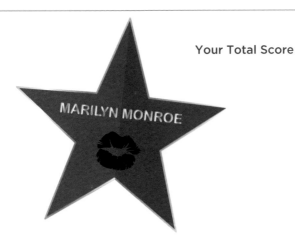

Results

10-18 Walt Disney

Walt Disney turned imagination and artistic innovation into one of the biggest companies in the country. He always looked to what was coming next, always improving and evolving to engage his audiences.

20-27 Marilyn Monroe

Marilyn Monroe was discovered while working in a factory and began modeling. Her career quickly took off and she became a top-billed Hollywood actress. Tired of being typecast and underpaid, she founded her own production company before her untimely and mysterious death.

28-35 Langston Hughes

Langston Hughes was an American poet, social activist, novelist, playwright, and columnist from Joplin, Missouri. He helped shape the Harlem Renaissance of the 1920s and is one of the most recognized names in modern poetry.

36-44 Marie Curie

Marie Curie won the Nobel Prize in physics for her work with radioactivity. During WWI, she invented mobile X-ray units for field hospitals. She also founded the Curie Institutes in Paris and in Warsaw, which are still centers of medical research today.

45-52 Rosa Parks

Rosa Parks was an icon of the civil rights movement. Though she is most famous for sparking the Montgomery bus boycott, she was a lifelong activist. Parks is a model of intelligence, resilience, and courage in the face of injustice.

53-60 Alexander Hamilton

Hamilton was one of the founder fathers for good reason. He was a self-made, self-educated man who fought both with his military skills and with his intellect to make the country free and prosperous.

WHICH
STEPHEN KING
BOOK WOULD YOU BE?

Stephen King has written more than fifty books. While each one has an element of the supernatural or otherworldly, they offer a wide variety of different kinds of stories. If you were to let your imagination run away with you, which book would you be?

1. Which weapon would you rather wield?
 A. Two sandalwood guns
 B. A croquet mallet
 C. A rifle
 D. Telekinesis
 E. A balloon

2. Would you rather live in:
 A. A small town in Maine
 B. A small town in Maine
 C. A small town in Maine
 D. The mountains of Colorado
 E. An alternate, post-apocalypse U.S.A.

3. Would you rather:
 A. Stop the world from ending
 B. Stop the holocaust from happening
 C. Stop bullying
 D. Stop mental illness
 E. Stop evil from prevailing

4. Would you rather:
 A. Rely on your community
 B. Rely on your closest friends
 C. Rely on your fate
 D. Rely on your family
 E. Rely on yourself

5. Would you rather:
 A. Stay in high school
 B. Stay in a haunted hotel
 C. Stay in the 1980s
 D. Stay in the 1960s
 E. Stay in an alternate universe

6. Would you rather face:
 A. Certain death
 B. An evil clown
 C. Murderous ghosts
 D. Mean teenagers
 E. An assassin

7. Would you rather learn:
 A. American history
 B. How to shoot a gun
 C. How to make friends
 D. How to write a play
 E. How to be more Pennywise

8. For Halloween, would you rather be:
 A. A clown
 B. Your favorite literary character
 C. A dead president
 D. A cowboy
 E. A princess

9. Would you rather:
 A. Have any friends at all
 B. Have no friends
 C. Have old friends back
 D. Have a few close friends
 E. Have better friends

10. If you were a villain, would you rather be:
 A. Popular
 B. A shape shifter
 C. Immortal
 D. Remembered forever
 E. A hero gone wrong

Score Guide

1. A=2, B=4, C=1, D=3, E=5 **2.** A=1, B=3, C=5, D=4, E=2 **3.** A=2, B=1, C=3, D=4, E=5

4. A=5, B=1, C=2, D=4, E=3 **5.** A=3, B=4, C=5, D=1, E=2 **6.** A=2, B=5, C=4, D=3, E=1

7. A=1, B=2, C=3, D=4, E=5 **8.** A=5, B=4, C=1, D=2, E=3 **9.** A=3, B=5, C=2, D=1, E=4

10. A=3, B=5, C=2, D=1, E=4

Your Total Score _____

Results

10-18 **11.22.63**

Anchored in American history with a time-travel element, 11.22.63 explores what would happen if one person made a change to the past. This book is also a mini-series made by Hulu and starring James Franco. Anyone who likes this would also like book or movie, The Green Mile.

19-26 **The Dark Tower**

This eight-book series is a multi-dimensional epic with a western feel. A redemption story of gunslingers on a long, complicated quest, the first book of the series, The Gunslinger, was made into a movie starring Idris Elba and Matthew McConaughey. Anyone who likes this would also enjoy The Stand.

27-34 **Carrie**

King's first novel and still one of his most famous, Carrie is the story of a girl who gets revenge on the classmates who reject her. A telekinetic girl with a cruel, fanatic mother Carrie was played by Sissy Spacek in the film version. Anyone who likes this would also like the short book, The Girl Who Loved Tom Gordon.

35-42 **The Shining**

The Shining tells the story of what happens when an unstable writer is isolated in a haunted hotel with his family. Spoiler alert: it isn't good. This movie made Jack Nicholson into an icon. Anyone who likes it would also enjoy Misery.

43-50 **It**

If you really like a scary story, It is considered King's scariest. A shape-shifting evil entity stalks through a small town on a murderous rampage and is never quite explained. This was only recently made into a movie. Anyone who likes this story would also enjoy 'Salem's Lot.

WHICH STEPHEN KING BOOK WOULD YOU BE?

Which Harry Potter Character Would You Be?

This mash-up quiz combines festivities with fictional favorites. Just like the range of holidays we celebrate throughout the year, the characters of Harry Potter offer something for everyone.

1. What is your favorite gift to receive?
 A. The latest gadget
 B. Memories
 C. Solitude
 D. Books
 E. Something personal
 F. A homemade sweater

2. What do you usually do for Halloween?
 A. Go to a Halloween party
 B. Dress up as a famous person you admire
 C. Scare people
 D. Give out candy
 E. Wear your normal clothes
 F. Coordinate costumes with your friends or siblings

3. Choose a minor holiday:
 A. Martin Luther King, Jr. day
 B. New Years Eve
 C. Independence Day
 D. Presidents Day
 E. Memorial Day
 F. St. Patrick's Day

4. What is your favorite holiday treat?
 A. Bertie Botts Every Flavor Beans
 B. Chocolate frogs
 C. Cauldron cakes
 D. Licorice wands
 E. Fizzing whizzbees
 F. Butterbeer

5. Who would you rather spend the holidays with?
 A. My family
 B. Anyone but my family
 C. My besties
 D. Myself
 E. My oldest, lifelong friends
 F. Wealthy relatives

6. Who would be your valentine?
 A. Someone who doesn't love me back
 B. Anyone I want
 C. My best friend's sister
 D. Valentine's Day is gross
 E. My childhood friend and equal
 F. Someone I thought I couldn't stand

7. What is the best part of a holiday party?
 A. Being with my friends
 B. Food
 C. Enchanted floating candles
 D. Presents
 E. Lurking
 F. Revelry

8. How do you find hidden gifts?
 A. Make my minions look for them
 B. With the dark arts
 C. With a well-executed spell
 D. With a spell that goes awry
 E. Asking a ghost to peek for me
 F. Look in the cabinet under the stairs

9. How do you spend a holiday vacation?
 A. Catching up on my reading
 B. In a fancy chalet
 C. Brooding
 D. Playing quidditch
 E. With my huge family
 F. Reliving memories

10. If you could replace the Easter Bunny with an animal, what would it be?
 A. A cat
 B. A stag
 C. A weasel
 D. A phoenix
 E. A snake
 F. A dragon

Your Total Score _____

Results

10-18 Hermione Granger

You are the brainy bookworm of the bunch, and you don't hesitate to show how smart you are. You are a perfectionist overachiever, but your friends only pretend to find it annoying because you are right most of the time.

19-27 Harry Potter

You're the hero who pulls everyone together. You are willing to take risks to do what is right. That may make you unpopular at times, but you don't mind because everyone will know in the end you made a difference.

28-36 Ron Weasley

You are lovable and loyal. You aren't naturally talented or charismatic, so you work hard to earn your achievements. You may get overshadowed at times, but you're always there when the chips are down.

36-44 Albus Dumbledore

You are wise on the inside but a bit eccentric on the outside. You are greatly respected and could rest on your laurels, but you're not above getting your hands dirty. A few trusted friends know you well, but to others you're a bit mysterious.

45-52 Severus Snape

Everyone loves a villain with a complex past. You keep people at arm's length and let them assume you're a grouch in order to keep your privacy. Underneath your dark exterior, there's a lot of talent and even more heart, though you don't often let it show.

53-60 Draco Malfoy

There would be no heroes without villains, and Malfoy is the ultimate teenage nemesis. He never misses an opportunity to advance himself and gain power over others. Malfoy is the hero if his own story.

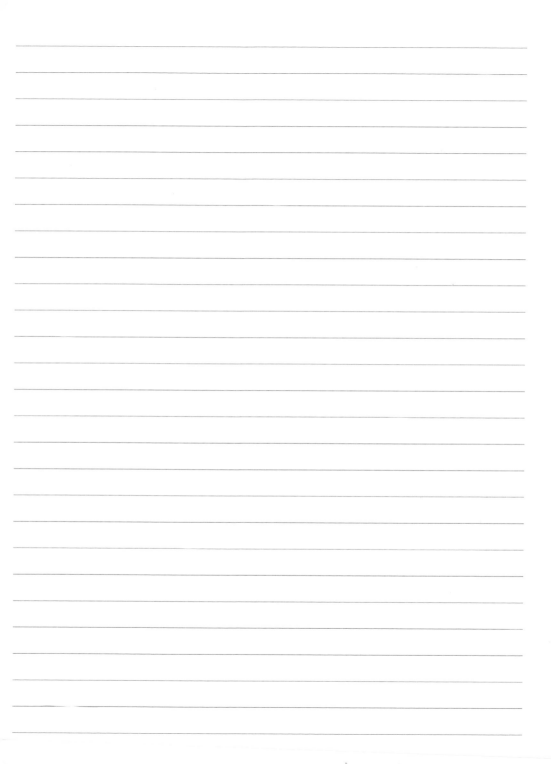

Looking for more?

Similar titles available by Piccadilly:

300 Writing Prompts

500 Writing Prompts

Complete the Story

Write the Story

Write the Poem

Journal THIS!

The Story of My Life

My Ultimate Bucket List

My Top 10

300 Drawing Prompts

500 Drawing Prompts

Complete This Drawing

Sketching Made Easy

Calligraphy Made Easy

Sketch THIS!

Rip it! Write it! Draw it!

WWW.PICCADILLYINC.COM

Awesome SOCIAL MEDIA Quizzes